# Treasures of
# IMPRESSIONISM AND
# POST-IMPRESSIONISM
## National Gallery of Art

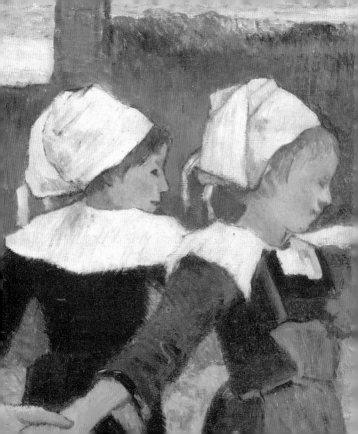

Treasures of
# IMPRESSIONISM AND
# POST-IMPRESSIONISM
National Gallery of Art

Florence E. Coman
Foreword by Earl A. Powell III

A TINY FOLIO™
Abbeville Press Publishers
New York London Paris

Front cover: Auguste Renoir. Detail of *A Girl with a Watering Can*, 1876. See page 96.

Back cover: Claude Monet. *Woman with a Parasol—Madame Monet and Her Son*, 1875. See page 77.

Spine: Paul Gauguin. *Self-Portrait*, 1889. See page 243.

Frontispiece: Paul Gauguin. Detail of *Breton Girls Dancing, Pont-Aven*, 1888. See page 241.

Page 18: James McNeill Whistler. Detail of *The White Girl (Symphony in White, No. 1)*, 1862. See page 33.

Page 21: Eugène Boudin. Detail of *Beach at Trouville*, 1864/65. See page 38.

Page 70: Mary Cassatt. Detail of *Little Girl in a Blue Armchair*, 1878. See page 136.

Page 73: Claude Monet. Detail of *The Artist's Garden at Vétheuil*, 1880. See page 78.

Page 154: Claude Monet. Detail of *The Japanese Footbridge*, 1899. See page 162.

Page 157: William Merritt Chase. Detail of *A Friendly Call*, 1895. See page 204.

Page 208: Pierre Bonnard. Detail of *Table Set in a Garden*, c. 1908. See page 271.

Page 211: Paul Gauguin. Detail of *The Bathers*, 1897. See page 252.

Editor: Nancy Grubb
Designer: Patrick Seymour
Production Editor: Abigail Asher
Production Supervisor: Matthew Pimm

For copyright and Cataloging-in-Publication Data, see page 319.

# CONTENTS

# FOREWORD

When Andrew W. Mellon, the founding benefactor of the National Gallery of Art, was asked whether he intended to add Impressionist works to his founding gift of 129 paintings, he replied that he hoped "others, who know this school better than I do, will contribute such works to the National Gallery." The Wideners, the Havemeyers, Chester Dale, W. Averell Harriman, John Hay Whitney, and Eugene and Agnes Meyer are among the many collectors who took up Mr. Mellon's challenge. Closer to our own time, Mr. Mellon's daughter, Ailsa Mellon Bruce, gave to the Gallery her collection of small-scale paintings by great French artists. And the founder's son and daughter-in-law, Mr. and Mrs. Paul Mellon, continue to this day to add to the trove of Impressionist paintings at the Gallery. The taste and generosity of these great benefactors have made the Gallery's collection of works of art from the Impressionist period world famous.

The reproductions in this tiny volume serve as the National Gallery's invitation to enjoy in person these and other timeless works of art. The Gallery serves the nation and the world in its exhibition galleries on the Mall in

Washington. We sincerely hope that you, too, will join the visitors who derive aesthetic and spiritual satisfaction from the nation's art treasures.

Earl A. Powell III, Director
National Gallery of Art, Washington

# INTRODUCTION

One single event, the sensational debut of Impressionism in Paris in April 1874, became the catalyst for a revolution that transformed the arts during the second half of the nineteenth century. A number of young artists presented the exhibition, the first public group show to be organized independently of the government-sanctioned Salon. Their audacious venture overturned contemporary artistic institutions and traditions, freeing artists to explore new forms of expression.

The Impressionist movement and the artists who created it are now almost universally beloved. Their paintings depict a world that looks more innocent and far more appealing than ours, with healthy and handsome men, women, and children populating bustling city streets and shops, comfortable suburban homes and parks, and tranquil fields in the countryside. Yet the familiarity and accessibility of Impressionist and Post-Impressionist works of art can obscure the complex artistic concerns addressed by these artists. Toward the end of his life Camille Pissarro gave some advice to a young follower. Pragmatic rather than theoretical, his words provide a rough working definition of Impressionism:

were no longer necessary. The 1886 show was the last Impressionist exhibition, and the group disbanded. Nevertheless, the Impressionist epithet stuck to the group, especially its most famous members.

The successor to Impressionism is usually called Post-Impressionism. Unlike the earlier term, Post-Impressionism does not define a style or movement. Rather, it was coined by the English artist and critic Roger Fry in 1910 to identify the variety of styles that had evolved out of Impressionism toward the middle of the 1880s. It is usually associated with four principal artists: Cézanne, Gauguin, Seurat, and Vincent van Gogh. Works by the Post-Impressionist masters are distinctive in appearance; Cézanne's planes, Gauguin's lush color harmonies, Seurat's dots, and van Gogh's forceful brushwork are hallmarks of their individual styles. Idiosyncratic though each artist's work was, one salient characteristic of Post-Impressionism as a whole can be discerned: the naturalist and realist impulses that had been a driving force of Impressionism were, with Post-Impressionism, supplanted by largely symbolic and non-naturalistic sources of inspiration.

Art in France during the nineteenth century was not a logical progression from one -ism to another along a smooth path toward Fauvism, Cubism, and subsequent movements of the twentieth century. The Impressionist revolution was indeed a revolution, one whose import

Impressionism as an institution parallel to the Salon, the revised title may have suggested that painting was the principal medium of Impressionism. However, graphic arts were also a distinct presence at the exhibitions. Works on paper—pastels, watercolors, drawings, and prints—were displayed at all eight exhibitions, and Degas, Pissarro, and Mary Cassatt in particular explored printmaking as a fine art rather than as a purely mechanical means of disseminating their art to a broader audience. Sculpture did not appear until the sixth exhibition, in 1881, when the most discussed work was Degas's *Little Dancer Fourteen Years Old* (page 133). Contemporary audiences accustomed to idealized statues in white marble or bronze were shocked by the *Little Dancer*—a statue of an awkward teenage girl made of flesh-tinted wax and wearing a linen-and-muslin ballet dress, satin-covered slippers, and a wig of animal hair tied with a real fabric ribbon. With this work Degas broke all the academic conventions for sculpture and intentionally blurred the barriers between art and reality.

The eighth Impressionist exhibition, in 1886, was dominated by the work of Georges Seurat, an artist brought into the group by Pissarro, who had himself adopted Seurat's Neo-Impressionist technique. By then the original Impressionists were beginning to attain a degree of popular success, and their group exhibitions

15

Favorable viewing conditions—good lighting and ample space between paintings—were considered essential by the Impressionists. In addition, they wanted to exhibit more than the two works allowed by Salon rules, and they believed that no jury should be able to control which works an artist could display. To guarantee the viewing conditions they needed, the Impressionists decided that they had to organize their own exhibition.

Selecting a name that would describe the diverse group of exhibitors—which included Claude Monet, Auguste Renoir, Camille Pissarro, Edgar Degas, Paul Cézanne, Berthe Morisot, and Alfred Sisley—proved impossible. After some contention they finally chose to emphasize their legitimacy with a neutral name and carefully designated themselves as the "Corporation of Artists: Painters, Sculptors, Printmakers, etc." They arranged their work in a few rented rooms on a fashionable Parisian boulevard and opened their doors a month before the 1874 Salon. The show attracted attention and visitors were numerous, but the critical reception was mixed. Some were receptive to their innovations and praised the group for breaking with the Salon system, but most reviews by established writers were harsh and derisive.

The most notorious review was a satiric piece by the conservative journalist Louis Leroy. He ignored the group's neutral name and—noting their unmixed

pigments and broken brushwork (characteristics of unfinished sketches known as "studies" or "impressions") as well as one work exhibited by Monet with the title *Impression, Sunrise* (Musée Marmottan, Paris)—he sarcastically dubbed them Impressionists. The review, an invented dialogue between Leroy and an apparently fictional academic landscape painter named Joseph Vincent, cleverly articulated a variety of serious objections to the artists and their enterprise. Leroy began his commentary by noting, "The rash man had come there without suspecting anything; he thought that he would see the kind of painting one sees everywhere, good and bad, rather bad than good, but not hostile to good artistic manners, devotion to form, and respect for the masters." These comments make clear that Leroy considered the Impressionists' paintings inferior, and that he objected even more vigorously to their deviation from what he considered artistic decency. Other journalists condemned the exhibition as a revolutionary, even anarchistic assault on France's cultural institutions.

In Leroy's review the academic painter, studying a landscape, lamented, "Oh, Corot, Corot, what crimes are committed in your name!" Jean-Baptiste-Camille Corot, the most prolific and influential landscape painter of the nineteenth century, had declined an invitation to join the Impressionist exhibition, but his influence was

clearly felt in many of the works shown there by artists such as Monet, Morisot, Pissarro, Renoir, and Sisley. Corot, like many other artists, had sketched outdoors but used his sketches to create works in the studio. These works had the finish, particularly with regard to paint handling and compositional balance, that was an integral element of academic art. The Impressionists, however, not only made sketches but also painted finished works in the open, which transformed their style by preserving the spontaneity of direct observation. They adopted colors that more accurately reflected actual visual experience and avoided using blacks and browns for shadows and modeling. As a result, their paintings emphasized color, light, and atmospheric effects. Moreover, their relatively loose and open brushwork— which was immediately recognized as a hallmark of the movement—underscored their freedom from the meticulously detailed academic manner that previously had been central to French painting.

Elements of the Impressionist style had originally been developed by precursors such as Corot, Gustave Courbet, and Edouard Manet, and by the mid-1870s Manet was working in a wholly Impressionist idiom. Nonetheless, he was still hoping for official recognition and refused to show with the Impressionists. While he continued submitting work to the Salon, his Impressionist

colleagues rejected the authority that institution represented. Their persistence in seeking acceptance and legitimacy by appealing directly to the public was a crucial component of the Impressionist enterprise. Despite the generally negative public response to their 1874 exhibition and the financially devastating outcome of an auction of paintings by Monet, Morisot, Renoir, and Sisley in 1875, the group carried on, holding seven more exhibitions before finally disbanding in 1886. The formulation of the Impressionist style and movement had been collaborative, but by the early 1880s individual artists had developed in different directions. Not all Impressionists adopted the Impressionist style of painting. Works by Degas, for example, are more typically realist and look different from those by Monet and Renoir, yet Degas was also an Impressionist. Membership in the group was flexible, and its exhibitions varied as the group gained and lost adherents with styles as diverse as those of Cézanne, Paul Gauguin, and Sisley. Only one artist, Pissarro, participated in all eight group manifestations.

Even the group's name changed. The 1874 title, "Corporation of Artists: Painters, Sculptors, Printmakers, etc.," was abandoned in subsequent exhibitions in favor of "Exhibition of Painting," accompanied by the names of the individual artists. If the original designation had been adopted to signal the legitimacy and inclusiveness of

extended beyond the content and technique of their paintings. By legitimizing new forms of expression, the Impressionists helped to free themselves and their successors from the tyranny of the Academy.

As early as 1883 a perceptive critic, Jules Laforgue, recognized the Impressionists' achievement:

> Some of the liveliest, most daring painters one has ever known, and also the most sincere, living as they do in the midst of mockery and indifference—that is, almost in poverty, with attention only from a small section of the press—are today demanding that the State have nothing to do with art, . . . that there be no more medals or rewards, and that artists be allowed to live in that anarchy which is life, which means everyone left to his own resources, and not hampered or destroyed by academic training which feeds on the past. No more official beauty; the public, unaided, will learn to see for itself and will be attracted naturally to those painters whom they find modern and vital. No more official salons and medals than there are for writers. Like writers working in solitude and seeking to have their productions displayed in their publishers' windows, painters will work in their own way and seek to have their paintings hung in galleries.

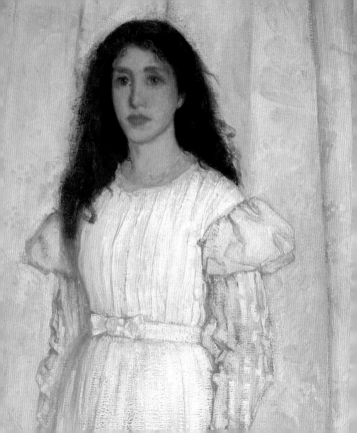

# PRECURSORS TO IMPRESSIONISM

The art world was in a ferment as Impressionism arose in the 1860s. At the beginning of the decade—when Claude Monet, Auguste Renoir, Alfred Sisley, and Frédéric Bazille were students together in Charles Gleyre's studio—the younger artists greatly admired the leaders of the avant-garde, particularly Gustave Courbet and Edouard Manet. A realist, Courbet challenged traditional ideas about art by painting unsentimental depictions of peasants and their activities on the grand scale usually reserved for history painting. The dispassionate modernity of Manet's subjects—as in *The Old Musician* of 1862 (page 48)—influenced the younger generation, as did his style. Manet placed pigments side by side, as in a sketch, rather than using the smoothly blended tones prescribed by the Academy, and his technique enabled him to preserve the immediacy of the scenes he observed. Eugène Boudin, known for *plein-air* depictions of tourists at resorts along the Normandy coast, taught Monet his practice of working in the open to record precise effects of light and atmosphere, an experience instrumental in the development of Impressionism.

Specific events also shaped the development of Impressionism. In 1863 rejections by the Salon jury were so numerous that Emperor Napoleon III was forced to institute a Salon des Refusés. Manet's *Olympia* (Musée d'Orsay, Paris) and *The White Girl* by American James McNeill Whistler (page 33) scandalized visitors there, while works shown by Camille Pissarro and Paul Cézanne passed unnoticed. The younger generation of avant-garde artists was inspired not only by various aspects of work by Courbet, Manet, Boudin, and Whistler, but also by their defiance of established artistic conventions. The influence of these highly regarded precursors proved critical to the emergence of Impressionism in the late 1860s and 1870s.

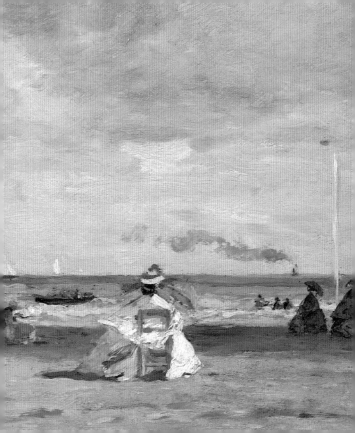

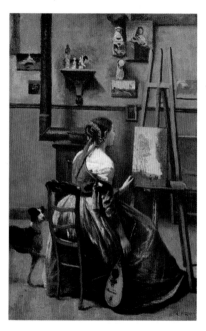

JEAN-BAPTISTE-CAMILLE COROT (1796–1875)
*The Artist's Studio,* c. 1855/60
Oil on wood, 24⅜ x 15¾ in. (61.9 x 40 cm)

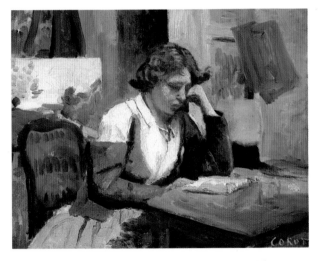

JEAN-BAPTISTE-CAMILLE COROT (1796–1875)
*Young Girl Reading,* 1868–70
Oil on canvas, 12½ x 16⅛ in. (31.6 x 41 cm)

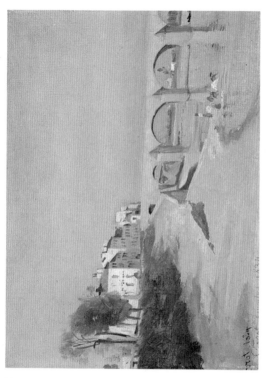

Jean-Baptiste-Camille Corot (1796–1875)
*River Scene with Bridge*, 1834
Oil on canvas, 9⅞ x 13⅜ in. (25 x 33.8 cm)

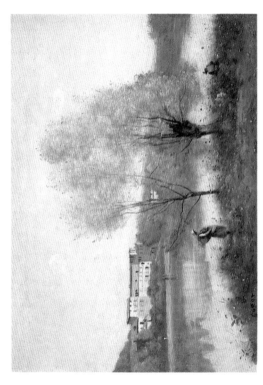

JEAN-BAPTISTE-CAMILLE COROT (1796–1875)
*Ville d'Avray*, c. 1867/70
Oil on linen, 19⅜ x 25⅝ in. (49.2 x 65.3 cm)

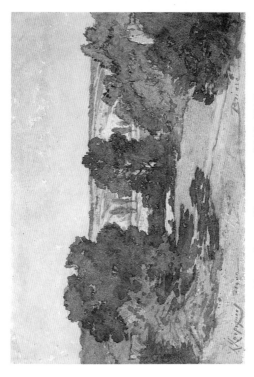

HENRI-JOSEPH HARPIGNIES (1819–1916)
*Briare*, 1902. Watercolor over graphite on paper,
7¾ x 11⅛ in. (19.6 x 28.1 cm)

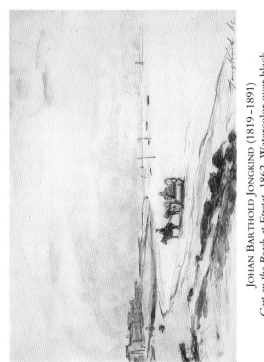

JOHAN BARTHOLD JONGKIND (1819–1891)
*Cart on the Beach at Etretat*, 1862. Watercolor over black chalk on paper, 9¼ x 13⅝ in. (23.4 x 34.4 cm)

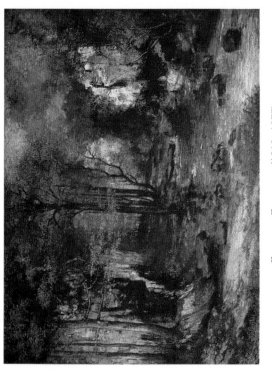

GUSTAVE COURBET (1819 – 1877)
*The Stream*, 1855
Oil on canvas, 41 x 54 in. (104.1 x 137.2 cm)

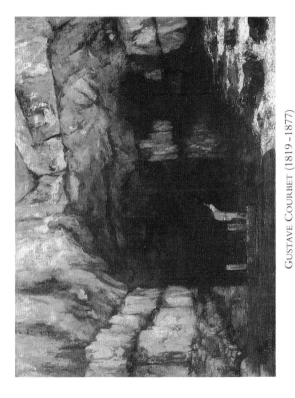

GUSTAVE COURBET (1819–1877)
*La Grotte de la Loue*, c. 1865
Oil on canvas, 38¾ x 51⅜ in. (98.4 x 130.4 cm)

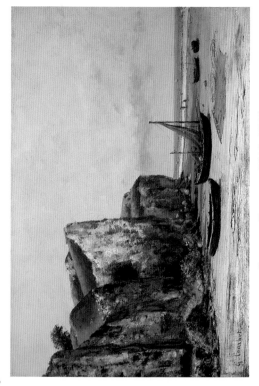

GUSTAVE COURBET (1819–1877)
*Beach in Normandy*, c. 1869
Oil on canvas, 24⅛ x 35½ in. (61.3 x 90.2 cm)

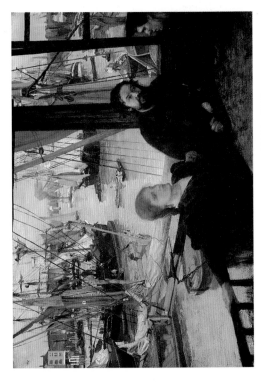

JAMES MCNEILL WHISTLER (1834–1903)
*Wapping on Thames*, 1860/64
Oil on canvas, 28⅜ x 40⅛ in. (72 x 101.8 cm)

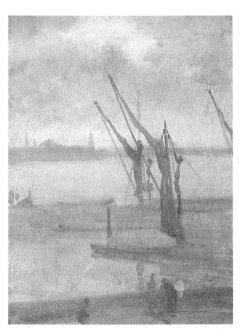

JAMES MCNEILL WHISTLER (1834 –1903)
*Chelsea Wharf: Grey and Silver*, c. 1875
Oil on canvas, 24¼ x 18⅛ in. (61.5 x 46 cm)

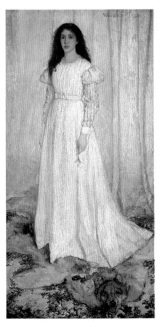

JAMES McNEILL WHISTLER (1834–1903)
*The White Girl (Symphony in White, No. 1),* 1862
Oil on canvas, 84½ x 42½ in. (214.7 x 108 cm)    33

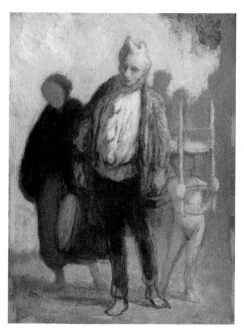

HONORÉ DAUMIER (1808–1879)
*Wandering Saltimbanques,* c. 1847/50
34    Oil on wood, 12⅞ x 9¾ in. (32.6 x 24.8 cm)

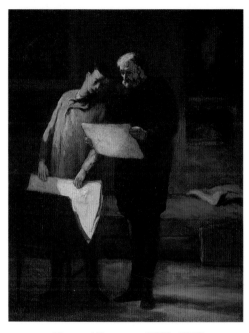

HONORÉ DAUMIER (1808 –1879)
*Advice to a Young Artist,* probably after 1860
Oil on canvas, 16⅛ x 12⅞ in. (41 x 32.7 cm)

35

Eugène Boudin (1824–1898)
*Beach Scene*, 1862
Oil on wood, 12½ x 19 in. (31.7 x 48.2 cm)

EUGÈNE BOUDIN (1824–1898)
*Jetty and Wharf at Trouville*, 1863
Oil on wood, 13⁵⁄₈ x 22³⁄₄ in. (34.6 x 57.8 cm)

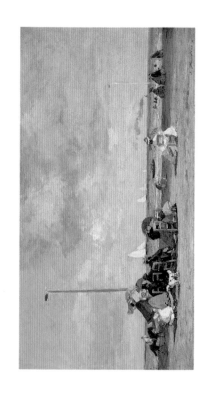

Eugène Boudin (1824–1898)
*Beach at Trouville,* 1864/65
Oil on wood, 10¼ x 18⅞ in. (25.9 x 47.9 cm)

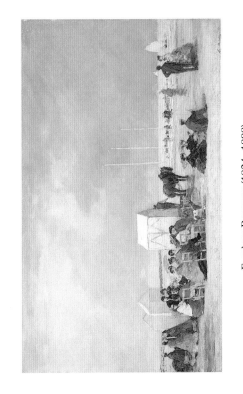

EUGÈNE BOUDIN (1824 – 1898)
*Bathing Time at Deauville*, 1865
Oil on wood, 13⅝ x 22¾ in. (34.5 x 57.9 cm)

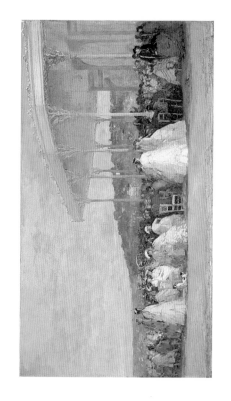

EUGÈNE BOUDIN (1824–1898)
*Concert at the Casino of Deauville*, 1865
Oil on canvas, 16½ x 28¾ in. (41.7 x 73 cm)

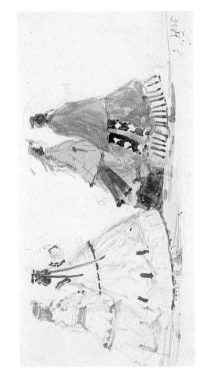

EUGÈNE BOUDIN (1824–1898)

*Four Ladies in Crinolines Walking at Trouville*, 1865. Watercolor
over graphite on paper, sight size: 4⅞ x 9⅜ in. (12.5 x 24 cm)

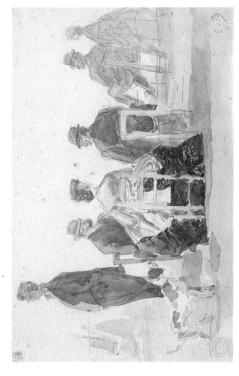

EUGÈNE BOUDIN (1824–1898)
*Ladies and Gentlemen Seated on the Beach with a Dog*, 1866
Watercolor over graphite on paper,
7 x 10⅞ in. (17.7 x 27.6 cm)

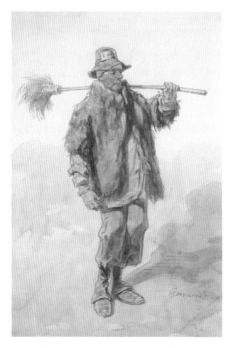

Paul Gavarni (1804–1866)
*The Street Sweeper,* c. 1848/52. Watercolor, gouache, and red
chalk on paper, 12⅝ x 8¼ in. (31.9 x 20.8 cm)     43

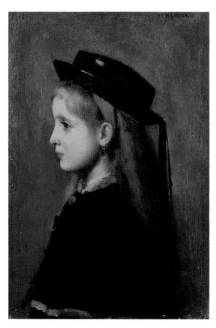

JEAN-JACQUES HENNER (1829–1905)
*Alsatian Girl*, 1873
Oil on wood, 10¾ x 7⅜ in. (27.2 x 18.7 cm)

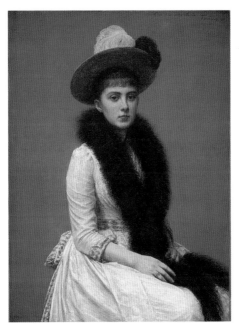

HENRI FANTIN-LATOUR (1836–1904)
*Portrait of Sonia*, 1890
Oil on canvas, 43 x 31⅞ in. (109.2 x 81 cm)

45

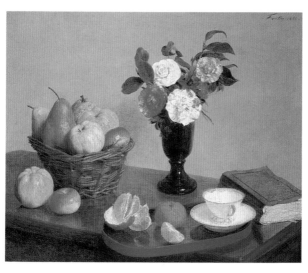

HENRI FANTIN-LATOUR (1836–1904)
*Still Life,* 1866
46    Oil on canvas, 24⅜ x 29½ in. (62 x 74.8 cm)

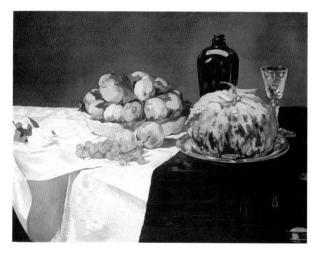

Edouard Manet (1832–1883)
*Still Life with Melon and Peaches,* c. 1866
Oil on canvas, 27⅛ x 36¼ in. (69 x 92.2 cm)

47

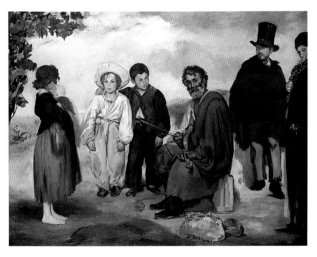

EDOUARD MANET (1832–1883)
*The Old Musician,* 1862
48    Oil on canvas, 73¾ x 97¾ in. (187.4 x 248.3 cm)

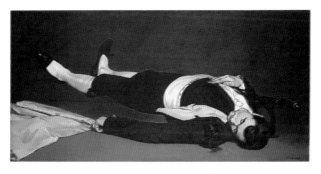

EDOUARD MANET (1832–1883)
*The Dead Toreador,* probably 1864
Oil on canvas, 29⅞ x 60⅜ in. (75.9 x 153.3 cm)    49

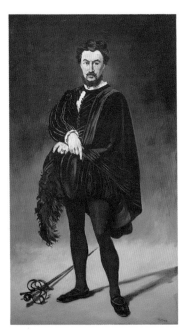

EDOUARD MANET (1832–1883)
*The Tragic Actor (Rouvière as Hamlet)*, 1866
Oil on canvas, 73¾ x 42½ in. (187.2 x 108.1 cm)

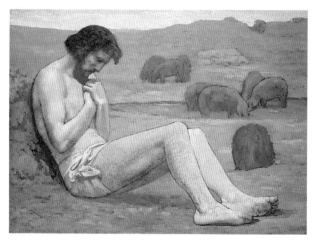

PIERRE PUVIS DE CHAVANNES (1824–1898)
*The Prodigal Son,* probably c. 1879
Oil on linen, 41⅞ x 57¾ in. (106.5 x 146.7 cm)

Frédéric Bazille (1841–1870)
*The Ramparts at Aigues-Mortes*, 1867
Oil on canvas, 23¾ x 39½ in. (60.3 x 103 cm)

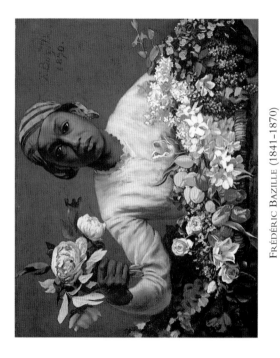

FRÉDÉRIC BAZILLE (1841-1870)
*Negro Girl with Peonies*, 1870
Oil on canvas, 23¾ x 29¾ in. (60.3 x 75.5 cm)

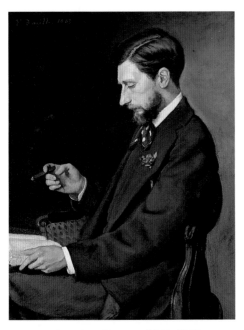

FRÉDÉRIC BAZILLE (1841–1870)
*Edmond Maître,* 1869

Oil on canvas, 32¾ x 25¼ in. (83.2 x 64 cm)

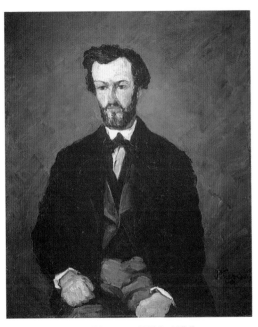

PAUL CÉZANNE (1839–1906)
*Antony Valabrègue*, 1866
Oil on canvas, 45¾ x 38¾ in. (116.3 x 98.4 cm)

55

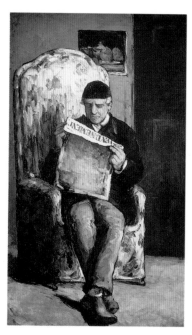

PAUL CÉZANNE (1839–1906)
*The Artist's Father*, 1866
Oil on canvas, 78⅛ x 47 in. (198.5 x 119.3 cm)

PAUL CÉZANNE (1839–1906)
*Father of the Artist* (verso), c. 1865/70
Graphite on paper, 11⅞ x 7¾ in. (30.1 x 19.6 cm) 57

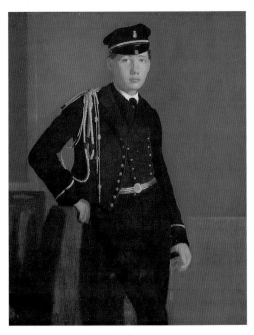

EDGAR DEGAS (1834–1917)
*Achille de Gas in the Uniform of a Cadet,* 1856/57
Oil on canvas, 25⅜ x 20⅛ in. (64.5 x 46.2 cm)

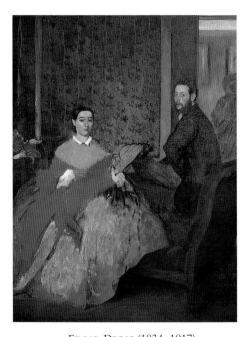

EDGAR DEGAS (1834–1917)
*Edmondo and Thérèse Morbilli,* c. 1865
Oil on canvas, 46⅛ x 35⅜ in. (117.1 x 89.9 cm)   59

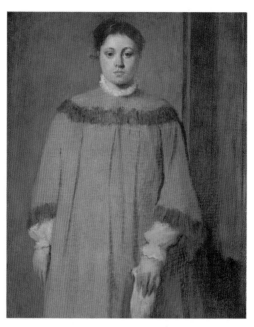

EDGAR DEGAS (1834–1917)
*Girl in Red*, c. 1866
Oil on canvas, 38⅞ x 31⅞ in. (98.9 x 80.8 cm)

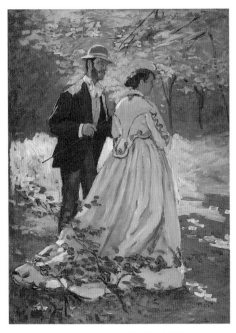

CLAUDE MONET (1840–1926)
*Bazille and Camille (Study for "Déjeuner sur l'Herbe"),* 1865
Oil on canvas, 36⅝ x 27⅛ in. (93 x 68.9 cm)    61

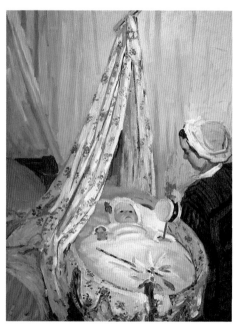

CLAUDE MONET (1840–1926)
*The Cradle—Camille with the Artist's Son Jean*, 1867
Oil on canvas, 45¾ x 34 in. (116.2 x 88.8 cm)

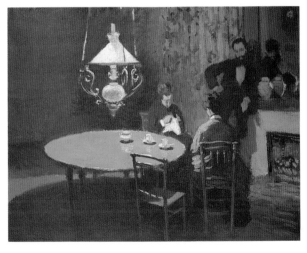

CLAUDE MONET (1840–1926)
*Interior, after Dinner,* 1868/69
Oil on canvas, 19⅞ x 25⅞ in. (50.5 x 65.7 cm)      63

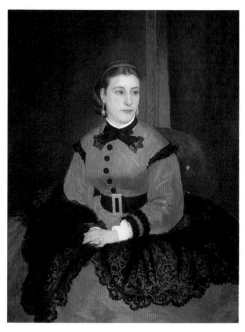

AUGUSTE RENOIR (1841–1919)
*Mademoiselle Sicot,* 1865
Oil on canvas, 45¾ x 35¼ in. (116 x 89.5 cm)

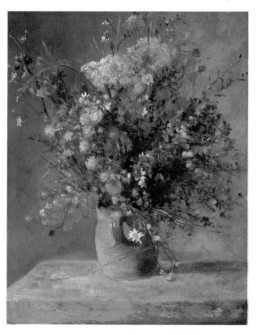

AUGUSTE RENOIR (1841–1919)
*Flowers in a Vase*, c. 1866
Oil on canvas, 32 x 25⅝ in. (81.3 x 65.1 cm)

65

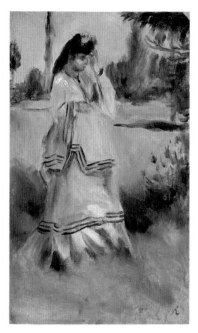

AUGUSTE RENOIR (1841–1919)
*Woman in a Park,* 1866
Oil on canvas, 10¼ x 6⅜ in. (26.1 x 16.1 cm)

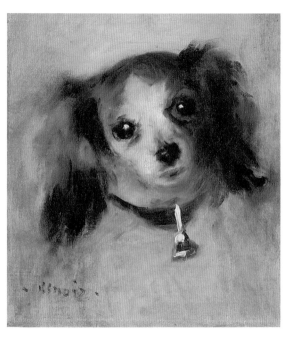

AUGUSTE RENOIR (1841–1919)
*Head of a Dog,* 1870
Oil on canvas, 8⅝ x 7⅞ in. (21.9 x 20 cm)

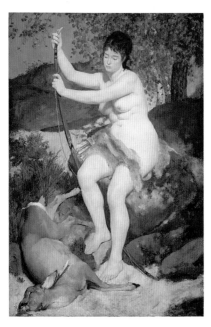

Auguste Renoir (1841-1919)
*Diana,* 1867
Oil on canvas, 77 x 51¼ in. (199.5 x 129.5 cm)

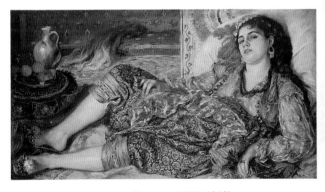

AUGUSTE RENOIR (1841–1919)
*Odalisque,* 1870
Oil on canvas, 27¼ x 48¼ in. (69.2 x 122.6 cm)

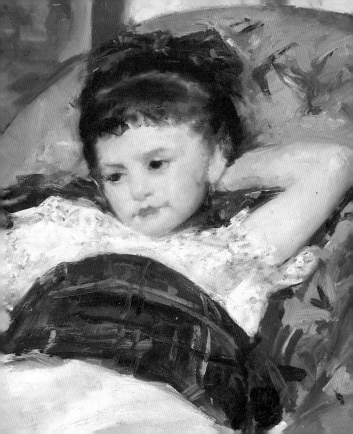

# THE IMPRESSIONISTS AND
# IMPRESSIONISM

Hundreds of paintings, graphics, and sculpture were shown in the eight original Impressionist exhibitions, and it is often difficult to securely link specific objects to the imprecise listings of generalized titles in the catalogs of those shows. Nonetheless, we know that several works selected by the artists for inclusion in their exhibitions are now at the National Gallery of Art. Auguste Renoir's *Dancer* (page 91) was criticized as "cottony" by a reviewer of the first exhibition. Camille Pissarro was chastised that year for the "vulgarity" of his peasant subjects in works such as *Orchard in Bloom, Louveciennes* (page 81). At the same time, however, Berthe Morisot was praised for the delicacy and charm of *The Harbor at Lorient* (page 108). The National Gallery of Art collection also incorporates three works that Edouard Manet submitted to the Salon rather than to the Impressionist exhibition in 1874. Two, *Gare Saint-Lazare* and *Polichinelle* (pages 144, 146), were accepted by the jury; the third, *Ball at the Opera* (page 145), was rejected.

Other works now in the gallery's collection that were shown at the original Impressionist exhibitions include *Skiffs* (page 117), by Gustave Caillebotte; *Girl*

*Arranging Her Hair* and probably *Little Girl in a Blue Armchair* (pages 142, 136), by Mary Cassatt; *Flowers in a Rococo Vase* (page 113), by Paul Cézanne; *Madame Camus* and *Girl Drying Herself* (pages 118, 125), by Edgar Degas; *Woman with a Parasol—Madame Monet and Her Son* and *Jerusalem Artichoke Flowers* (pages 77, 79), by Monet; *Hanging the Laundry out to Dry* and *In the Dining Room* (pages 109, 112), by Morisot; *Peasant Girl with a Straw Hat* (page 85), by Pissarro; and *Oarsmen at Chatou* (page 99), by Renoir. None of the Gallery's Sisleys can be identified with an exhibited work with any certainty.

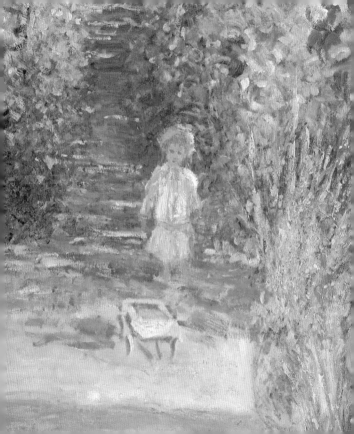

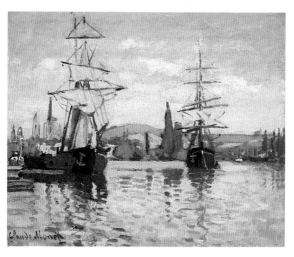

CLAUDE MONET (1840–1926)
*Ships Riding on the Seine at Rouen*, 1872/73
74     Oil on canvas, 14⅞ x 18⅜ in. (37.8 x 46.6 cm)

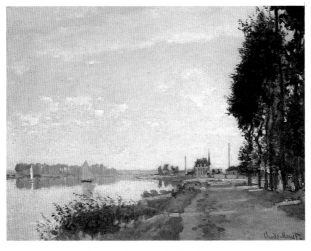

CLAUDE MONET (1840–1926)
*Argenteuil,* c. 1872
Oil on canvas, 19⅞ x 25⅝ in. (50.4 x 65.2 cm)      75

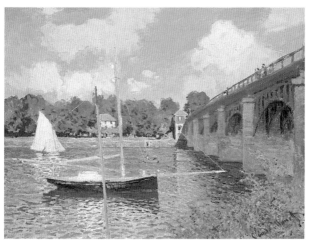

CLAUDE MONET (1840–1926)
*The Bridge at Argenteuil*, 1874
76    Oil on canvas, 23⅝ x 31⅜ in. (60 x 79.7 cm)

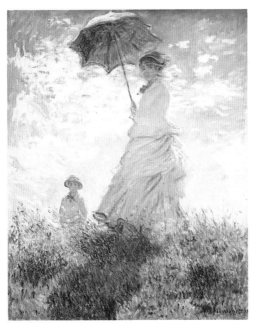

CLAUDE MONET (1840–1926)
*Woman with a Parasol—Madame Monet and Her Son,* 1875
Oil on canvas, 39⅜ x 31⅞ in. (100 x 81 cm)   77

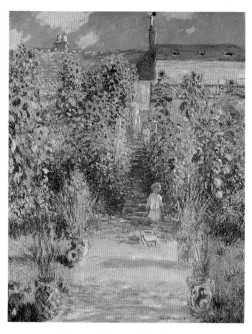

CLAUDE MONET (1840–1926)
*The Artist's Garden at Vétheuil,* 1880
Oil on canvas, 59⅝ x 47⅝ in. (151.4 x 121 cm)

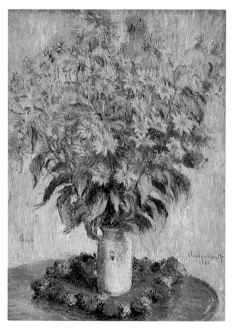

CLAUDE MONET (1840–1926)
*Jerusalem Artichoke Flowers,* 1880
Oil on canvas, 39¼ x 28¾ in. (99.6 x 73 cm)

79

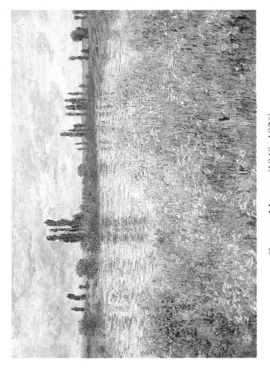

CLAUDE MONET (1840–1926)
*Banks of the Seine, Vétheuil*, 1880
Oil on canvas, 28⅞ x 39⅝ in. (73.4 x 100.5 cm)

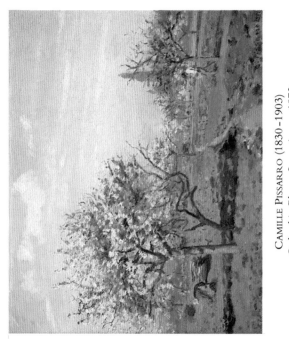

CAMILLE PISSARRO (1830–1903)
*Orchard in Bloom, Louveciennes*, 1872
Oil on canvas, 17¾ x 21⅝ in. (45.1 x 54.9 cm)

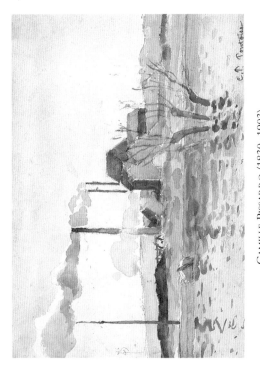

CAMILLE PISSARRO (1830–1903)
*Factory on the Oise at Pontoise*, 1873. Watercolor over graphite on paper, 7 x 9⅞ in. (17.7 x 25.1 cm)

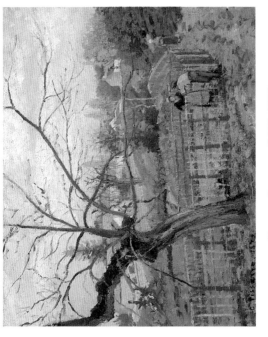

CAMILLE PISSARRO (1830–1903)
*The Fence*, 1872
Oil on canvas, 14⅞ x 18 in. (37.8 x 45.7 cm)

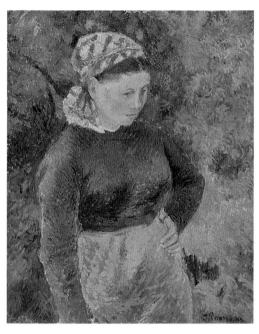

CAMILLE PISSARRO (1830–1903)
*Peasant Woman,* 1880
Oil on canvas, 28¾ x 23⅝ in. (73.1 x 60 cm)

84

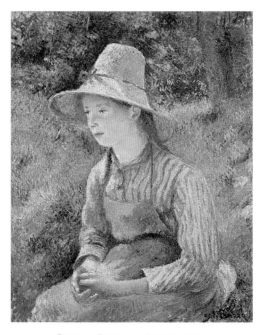

CAMILLE PISSARRO (1830–1903)
*Peasant Girl with a Straw Hat,* 1881
Oil on canvas, 28⅞ x 23½ in. (73.4 x 59.6 cm)

CAMILLE PISSARRO (1830–1903)
*Woman Working in a Garden,* late 1880s. Watercolor over
black chalk on paper, 10 x 6⅞ in. (25.2 x 17.4 cm)

CAMILLE PISSARRO (1830–1903)
*Cabbage Patch*, c. 1880. Graphite on paper, approximately 9⅞ x 6¾ in. (25 x 17 cm)

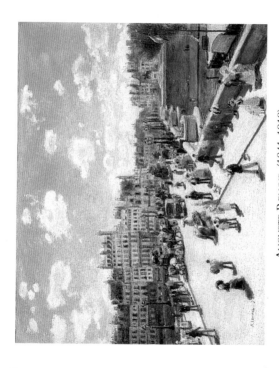

AUGUSTE RENOIR (1841–1919)
*Pont Neuf, Paris*, 1872
Oil on canvas, 29⅝ x 36⅞ in. (75.3 x 93.7 cm)

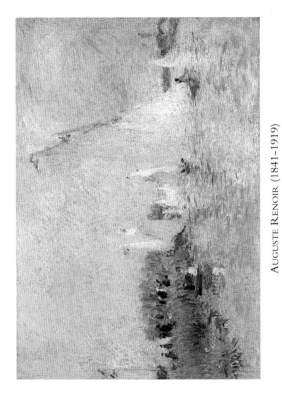

AUGUSTE RENOIR (1841-1919)
*Regatta at Argenteuil*, 1874
Oil on canvas, 12¾ x 18 in. (32.4 x 45.6 cm)

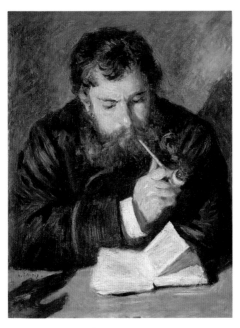

Auguste Renoir (1841-1919)
*Claude Monet*, 1872
90     Oil on canvas, 25⅝ x 19½ in. (65.1 x 49.4 cm)

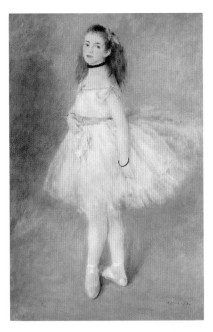

AUGUSTE RENOIR (1841–1919)
*The Dancer*, 1874
Oil on canvas, 56⅛ x 37⅛ in. (142.5 x 94.5 cm)

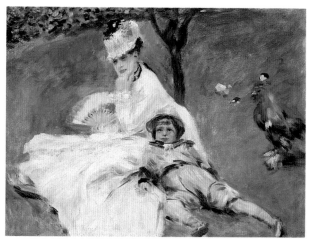

AUGUSTE RENOIR (1841–1919)
*Madame Monet and Her Son,* 1874
Oil on canvas, 19⅞ x 26¾ in. (50.4 x 68 cm)

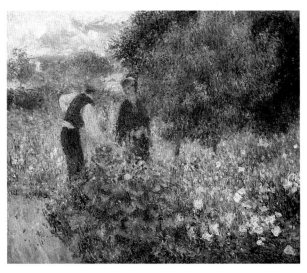

AUGUSTE RENOIR (1841–1919)
*Picking Flowers*, 1875
Oil on linen, 21⅜ x 25⅝ in. (54.3 x 65.2 cm)    93

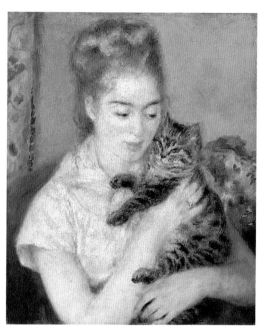

AUGUSTE RENOIR (1841–1919)
*Woman with a Cat,* c. 1875
94    Oil on canvas, 22 x 18¼ in. (56 x 46.4 cm)

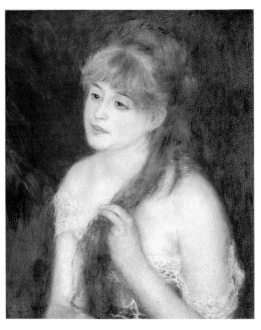

AUGUSTE RENOIR (1841–1919)
*Young Woman Braiding Her Hair,* 1876
Oil on canvas, 21⅞ x 18¼ in. (55.6 x 46.4 cm)     95

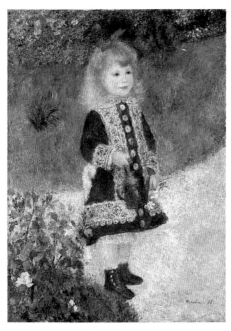

AUGUSTE RENOIR (1841-1919)
*A Girl with a Watering Can,* 1876
Oil on canvas, 39½ x 28¾ in. (100.3 x 73.2 cm)

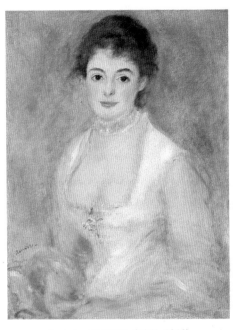

AUGUSTE RENOIR (1841–1919)
*Madame Henriot,* c. 1876
Oil on canvas, 26 x 19⅝ in. (65.9 x 49.8 cm)

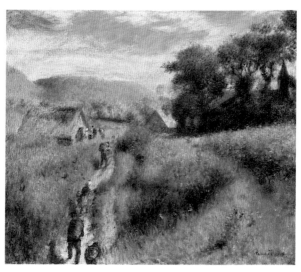

AUGUSTE RENOIR (1841-1919)
*The Vintagers*, 1879
Oil on canvas, 21¼ x 25¾ in. (54.2 x 65.4 cm)

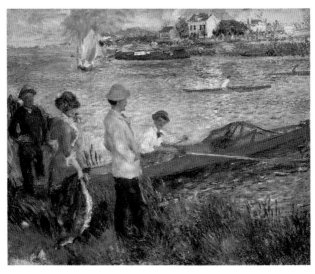

AUGUSTE RENOIR (1841–1919)
*Oarsmen at Chatou,* 1879
Oil on linen, 32 x 39½ in. (81.3 x 100.3 cm)

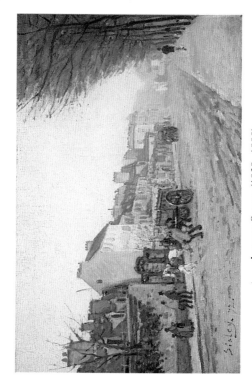

ALFRED SISLEY (1839–1899)
*Boulevard Héloïse, Argenteuil*, 1872
Oil on canvas, 15½ x 23½ in. (39.5 x 59.6 cm)

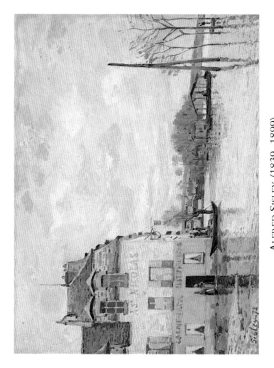

ALFRED SISLEY (1839–1899)
*Flood at Port-Marly*, 1872
Oil on canvas, 18¼ x 24 in. (46.4 x 61 cm)

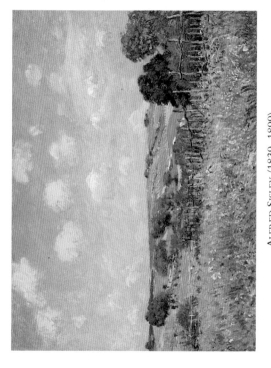

ALFRED SISLEY (1839-1899)
*Meadow*, 1875
Oil on canvas, 21⅝ x 28¾ in. (54.9 x 73 cm)

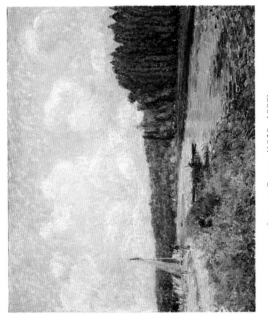

ALFRED SISLEY (1839–1899)
*The Banks of the Oise*, 1877/78
Oil on canvas, 21⅛ x 25½ in. (54.3 x 64.7 cm)

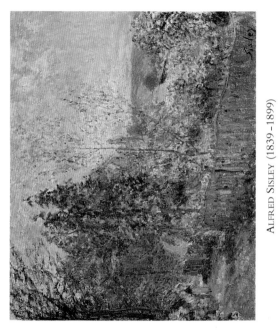

ALFRED SISLEY (1839–1899)
*The Road in the Woods*, 1879
Oil on canvas, 18¼ x 22 in. (46.3 x 55.8 cm)

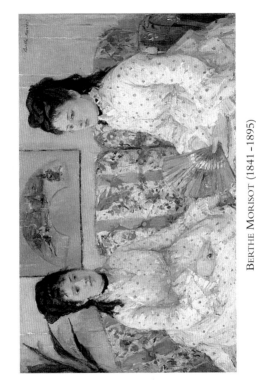

BERTHE MORISOT (1841–1895)
*The Sisters*, 1869
Oil on canvas, 20½ x 32 in. (52.1 x 81.3 cm)

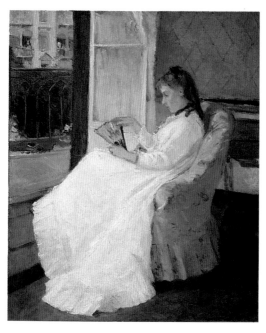

BERTHE MORISOT (1841–1895)
*The Artist's Sister at a Window*, 1869
Oil on canvas, 21⅝ x 18¼ in. (54.8 x 46.3 cm)

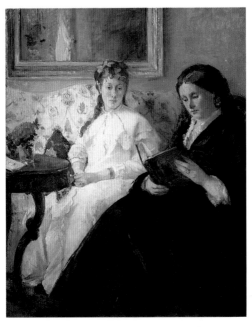

BERTHE MORISOT (1841–1895)
*The Mother and Sister of the Artist,* 1869/70
Oil on canvas, 39½ x 32¼ in. (101 x 81.8 cm)    107

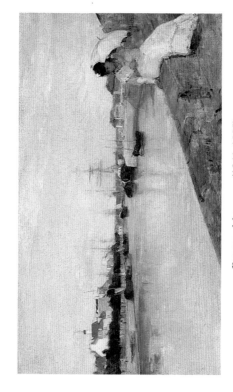

BERTHE MORISOT (1841–1895)
*The Harbor at Lorient*, 1869
Oil on canvas, 17⅛ x 28¾ in. (43.5 x 73 cm)

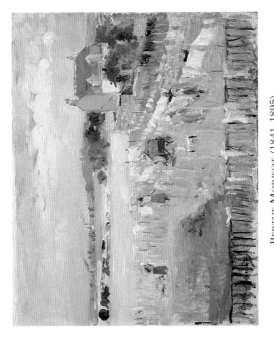

BERTHE MORISOT (1841-1895)
*Hanging the Laundry out to Dry*, 1875
Oil on canvas, 13 x 16 in. (33 x 40.6 cm)

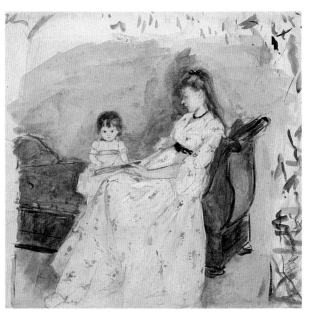

BERTHE MORISOT (1841–1895)
*The Artist's Sister Edma with Her Daughter, Jeanne,* 1872
Watercolor over graphite on paper,
approximately 9⅞ x 10¼ in. (25.1 x 25.9 cm)

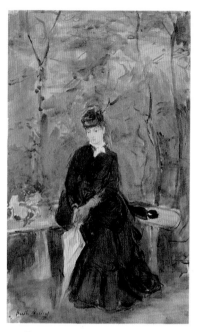

BERTHE MORISOT (1841–1895)
*The Artist's Sister Edma Seated in a Park,* 1864
Watercolor on paper, 9⅞ x 6 in. (24.9 x 15.1 cm)

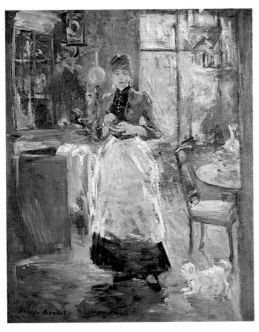

BERTHE MORISOT (1841–1895)
*In the Dining Room*, 1886
Oil on canvas, 24⅛ x 19¾ in. (61.3 x 50 cm)

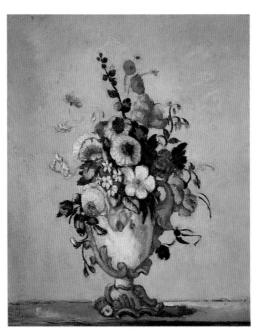

PAUL CÉZANNE (1839–1906)
*Flowers in a Rococo Vase*, c. 1876
Oil on canvas, 28¾ x 23½ in. (73 x 59.8 cm)

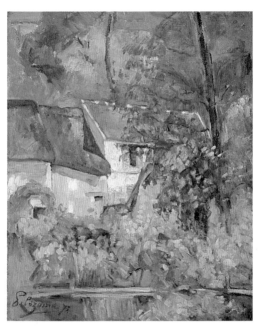

PAUL CÉZANNE (1839–1906)
*House of Père Lacroix*, 1873
Oil on canvas, 24⅛ x 20 in. (61.3 x 50.6 cm)

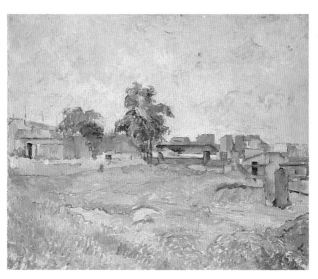

PAUL CÉZANNE (1839–1906)
*Landscape near Paris,* c. 1876
Oil on canvas, 19¾ x 23⅞ in. (50.2 x 60 cm)

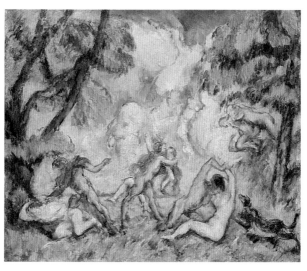

PAUL CÉZANNE (1839–1906)
*The Battle of Love,* c. 1880
Oil on linen, 14⅞ x 18¼ in. (37.8 x 46.2 cm)

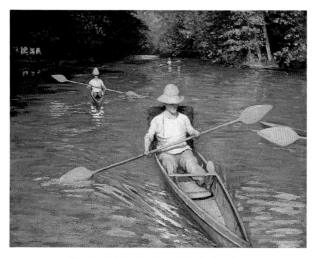

GUSTAVE CAILLEBOTTE (1848–1894)
*Skiffs,* 1877
Oil on canvas, 35 x 45¾ in. (88.9 x 116.2 cm)   117

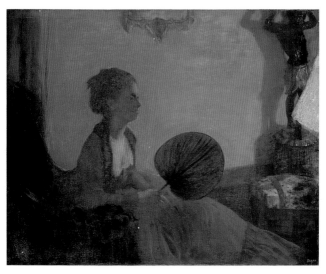

EDGAR DEGAS (1834–1917)
*Madame Camus,* 1869/70
118      Oil on canvas, 28⅝ x 36¼ in. (72.7 x 92.1 cm)

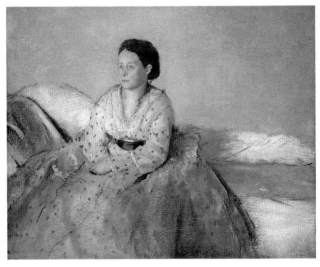

EDGAR DEGAS (1834–1917)
*Madame René de Gas,* 1872/73
Oil on canvas, 28¾ x 36¼ in. (72.9 x 92 cm)        119

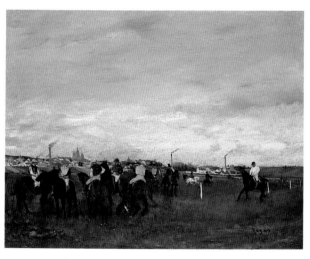

EDGAR DEGAS (1834–1917)
*The Races,* before 1873
Oil on wood, 10½ x 13¾ in. (26.5 x 35 cm)

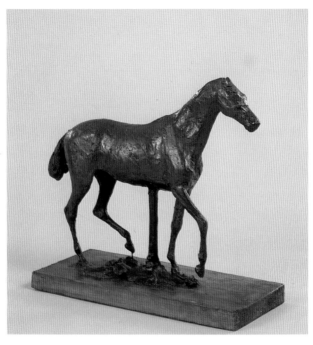

EDGAR DEGAS (1834–1917)
*Horse Walking,* probably before 1881
Reddish wax, height: 8¼ in. (21 cm)

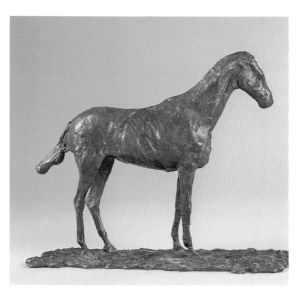

EDGAR DEGAS (1834–1917)
*Study of a Mustang*, c. 1860/62, cast 1919/21
Bronze, height: 8¾ in. (22.2 cm)

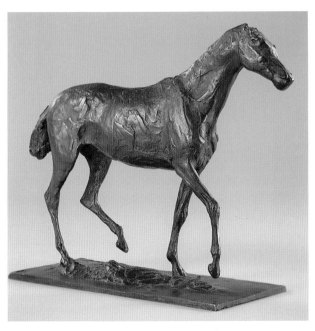

EDGAR DEGAS (1834–1917)
*Horse Walking,* c. 1860/70, cast 1919/21
Bronze, height: 8⅜ in. (21.3 cm)

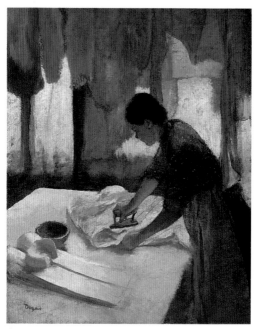

EDGAR DEGAS (1834–1917)
*Woman Ironing,* begun c. 1876, completed c. 1887
Oil on canvas, 32 x 26 in. (81.3 x 66 cm)

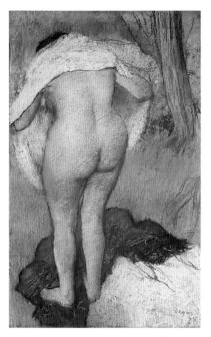

EDGAR DEGAS (1834–1917)
*Girl Drying Herself,* 1885
Pastel on paper, 31½ x 20⅛ in. (80.1 x 51.2 cm)

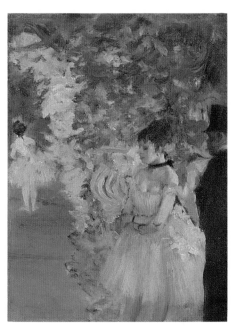

EDGAR DEGAS (1834–1917)
*Dancers Backstage,* 1876/83
126     Oil on canvas, 9½ x 7⅞ in. (24.2 x 18.8 cm)

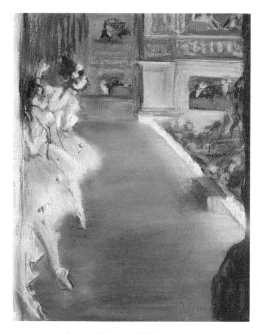

EDGAR DEGAS (1834–1917)
*Dancers at the Old Opera House,* c. 1877
Pastel over monotype, 8⅝ x 6¾ in. (21.8 x 17.1 cm)    127

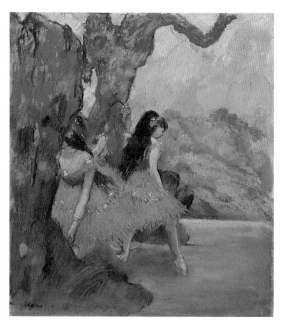

EDGAR DEGAS (1834–1917)
*Ballet Dancers,* c. 1877. Pastel and gouache over
monotype, 11¾ x 10⅝ in. (29.7 x 26.9 cm)

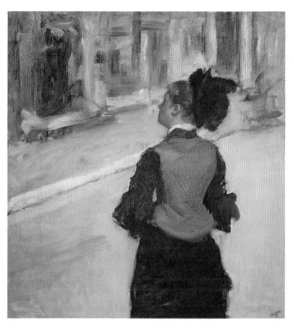

EDGAR DEGAS (1834–1917)
*Woman Viewed from Behind*, n.d.
Oil on canvas, 32 x 29¾ in. (81.3 x 75.6 cm)

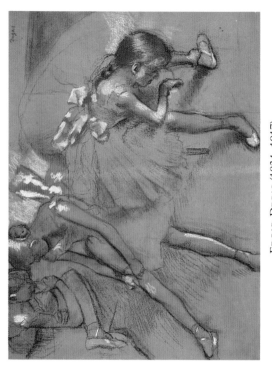

EDGAR DEGAS (1834–1917)
*Three Dancers Resting*, c. 1880. Black chalk and pastel on paper,
18½ x 24⅜ in. (47 x 61.9 cm)

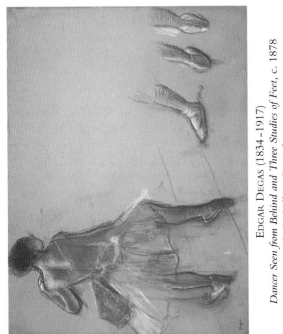

EDGAR DEGAS (1834–1917)
*Dancer Seen from Behind and Three Studies of Feet*, c. 1878
Black chalk and pastel on paper,
19 x 24 in. (45.6 x 59.8 cm)

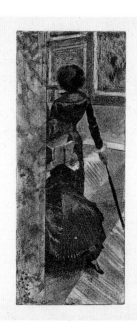

EDGAR DEGAS (1834–1917)
*Mary Cassatt at the Louvre: The Paintings Gallery*, c. 1879/80
Etching, aquatint, drypoint, and electric crayon,
sheet: 14⅝ x 8⅞ in. (37 x 22.5 cm)

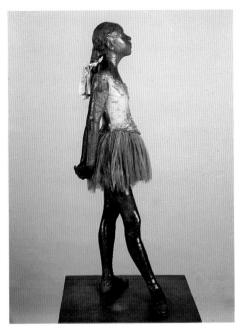

EDGAR DEGAS (1834–1917)
*Little Dancer Fourteen Years Old,* 1878/81. Wax, hair, fabric, and
wood base, height: 39 in. (99 cm)   133

JAMES-JACQUES-JOSEPH TISSOT (1836–1902)
*Hide and Seek*, c. 1877
134     Oil on wood, 28⅞ x 21¼ in. (73.4 x 53.9 cm)

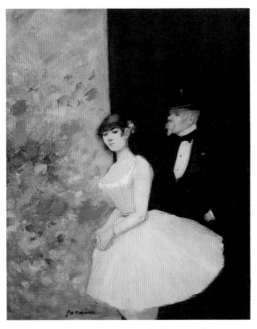

JEAN-LOUIS FORAIN (1852–1931)
*Behind the Scenes,* c. 1880
Oil on canvas, 18¼ x 15⅛ in. (46.4 x 38.4 cm)

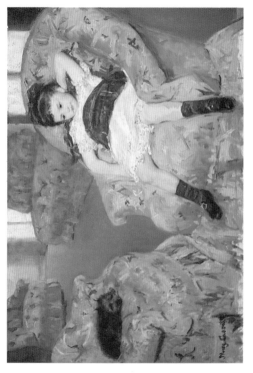

MARY CASSATT (1844–1926)
*Little Girl in a Blue Armchair*, 1878
Oil on canvas, 35½ x 51⅛ in. (89.5 x 129.8 cm)

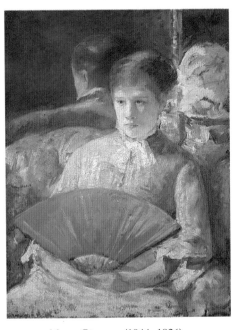

MARY CASSATT (1844–1926)
*Miss Mary Ellison*, c. 1880
Oil on canvas, 33¾ x 25⅝ in. (85.5 x 65.1 cm)   137

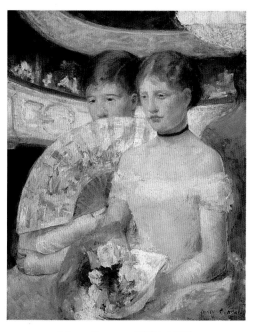

MARY CASSATT (1844–1926)
*The Loge,* 1882
Oil on canvas, 31⅜ x 25⅛ in. (79.8 x 63.8 cm)

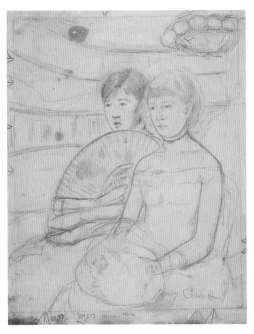

MARY CASSATT (1844–1926)
*The Loge* (recto), 1882. Graphite on paper,
approximately 11 x 8¾ in. (28 x 22.1 cm)

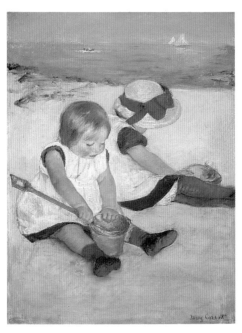

MARY CASSATT (1844–1926)
*Children Playing on the Beach*, 1884
Oil on canvas, 38⅜ x 29¼ in. (97.4 x 74.2 cm)

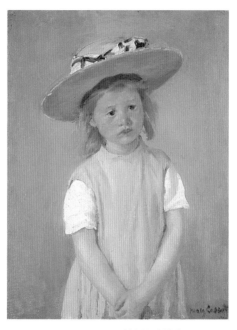

MARY CASSATT (1844–1926)
*Child in a Straw Hat,* c. 1886
Oil on canvas, 25¾ x 19⅜ in. (65.3 x 49.2 cm)     141

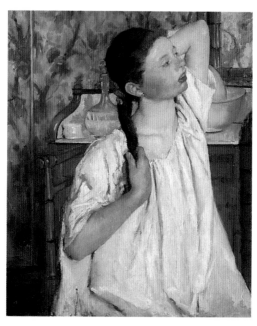

MARY CASSATT (1844–1926)
*Girl Arranging Her Hair*, 1886
Oil on canvas, 29⅝ x 24⅝ in. (75.1 x 62.5 cm)

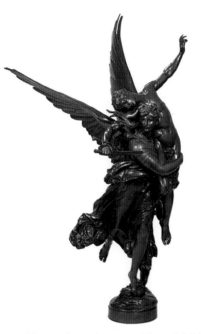

MARIUS-JEAN-ANTONIN MERCIÉ (1845–1916)
*Gloria Victis!*, c. 1874
Bronze, height: 55¼ in. (140.3 cm)                    143

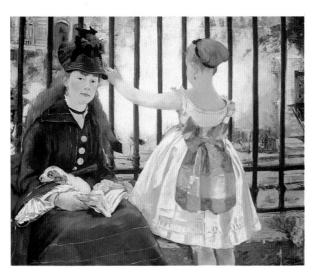

EDOUARD MANET (1832–1883)
*Gare Saint-Lazare,* 1873

Oil on canvas, 36 ¾ x 43 ⅞ in. (93.3 x 111.5 cm)

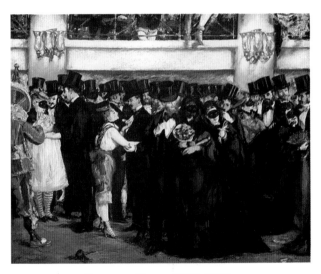

EDOUARD MANET (1832–1883)
*Ball at the Opera*, 1873
Oil on canvas, 23¼ x 28½ in. (59 x 72.5 cm)  145

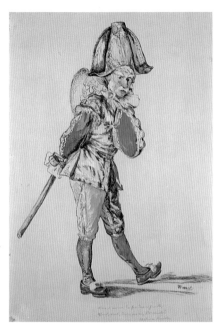

EDOUARD MANET (1832–1883)
*Polichinelle,* 1874. Lithograph in black, hand-colored with
gouache and watercolor, 18⅞ x 12¾ in. (48 x 32.3 cm)

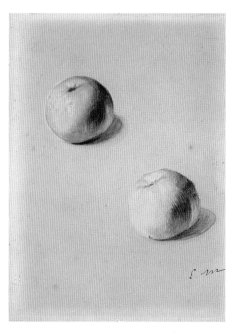

EDOUARD MANET (1832–1883)
*Two Apples*, 1880. Watercolor over graphite on paper,
7⅜ x 5½ in. (18.8 x 13.9 cm)                          147

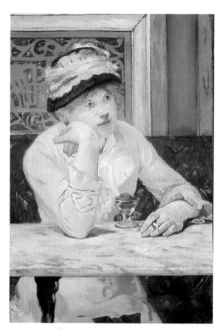

EDOUARD MANET (1832–1883)
*The Plum*, c. 1877
Oil on canvas, 29 x 19¾ in. (73.6 x 50.2 cm)

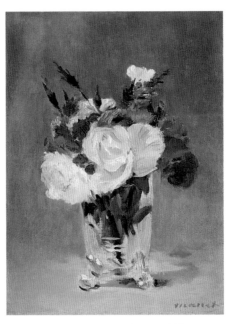

EDOUARD MANET (1832–1883)
*Flowers in a Crystal Vase*, c. 1882
Oil on canvas, 12⅞ x 9⅝ in. (32.6 x 24.3 cm)

EUGÈNE BOUDIN (1824–1898)
*Entrance to the Harbor, Le Havre*, 1883
Oil on canvas, 46⅞ x 63⅛ in. (119.1 x 160.4 cm)

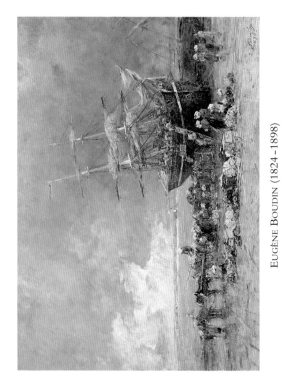

EUGÈNE BOUDIN (1824–1898)
*Return of the Terre-Neuvier*, 1875
Oil on canvas, 29 x 39⅝ in. (73.5 x 100.7 cm)

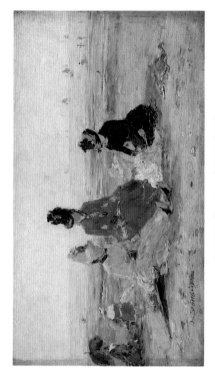

EUGÈNE BOUDIN (1824–1898)
*On the Beach, Trouville,* 1887
Oil on wood, 7½ x 12⅞ in. (18.4 x 32.7 cm)

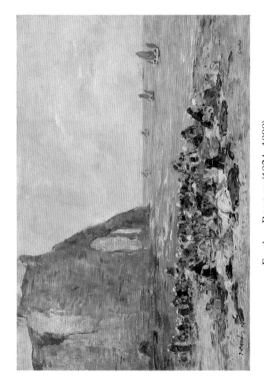

EUGÈNE BOUDIN (1824–1898)
*Washerwomen on the Beach of Etretat*, 1894
Oil on wood, 14⅝ x 21⅝ in. (37.2 x 54.9 cm)

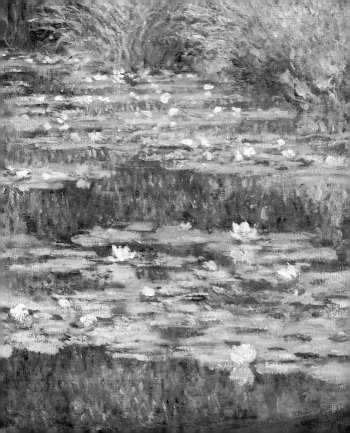

# THE IMPRESSIONISTS AFTER IMPRESSIONISM

Toward the middle of the 1880s a number of Impressionists became disaffected with the movement they had created, and the former comrades began to head in different directions. The seventh Impressionist exhibition, held in 1882, was in a sense the last Impressionist exhibition; its organizers—Camille Pissarro, Gustave Caillebotte, and the dealer Paul Durand-Ruel—persuaded Claude Monet, Auguste Renoir, and Alfred Sisley (all of whom had defected to the Salon) to return to show their work in a display of Impressionist art. A critical and commercial success, the exhibition was the last unified Impressionist display. The movement ended in 1886, having largely succeeded in its goal of creating a diverse and enlightened audience for art in France as well as elsewhere in Europe and America.

Renoir, following voyages to north Africa and Italy in the early 1880s, discarded elements of his Impressionist style and began to develop a linear manner strongly influenced by Jean-Auguste-Dominique Ingres. Toward the end of the 1880s the classical themes of still life and the female nude became the inspiration for his late style—a synthesis of crisp, linear form and softer, Impressionist

handling. Pissarro followed a different route, which carried him into Georges Seurat's orbit. Always open to new ideas and dissatisfied by the increasingly labored appearance of his own paintings (created by dense webs of brush strokes), Pissarro adopted Neo-Impressionism in the late 1880s; after Seurat's death in 1891 he reverted to an early Impressionist style. Toward the end of the 1880s Monet began to explore a new kind of painting using serial imagery. His series paintings broke from Impressionism in two critical respects: first, although they were begun in front of the motif, the paintings usually were extensively reworked in the studio and lacked the spontaneity integral to Impressionism; and second, the motif itself became less important than capturing specific effects of light, color, and mood.

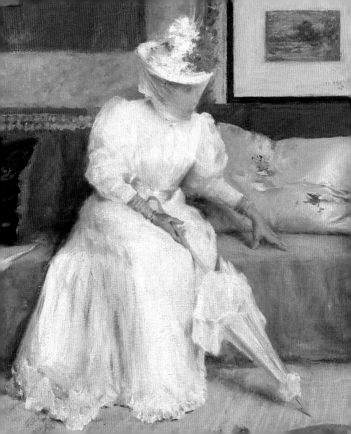

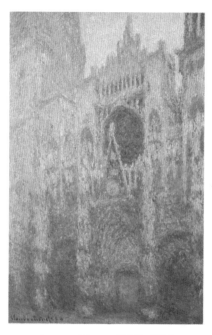

CLAUDE MONET (1840–1926)
*Rouen Cathedral, West Façade,* 1894
Oil on canvas, 39½ x 26 in. (100.4 x 66 cm)

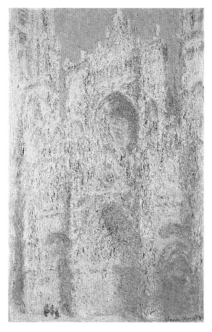

CLAUDE MONET (1840–1926)
*Rouen Cathedral, West Façade, Sunlight*, 1894
Oil on canvas, 39½ x 26 in. (100.2 x 66 cm)

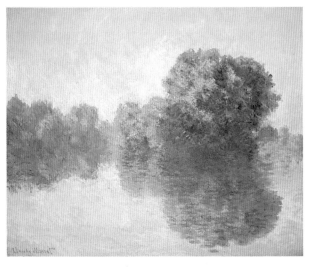

CLAUDE MONET (1840–1926)
*The Seine at Giverny,* 1897
Oil on canvas, 32⅛ x 39⅝ in. (81.6 x 100.3 cm)

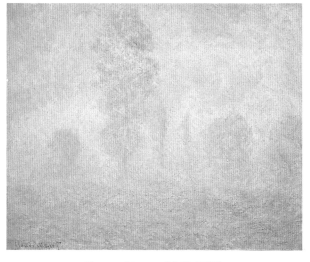

CLAUDE MONET (1840–1926)
*Morning Haze,* 1888
Oil on linen, 29⅛ x 36⅝ in. (74 x 92.9 cm)

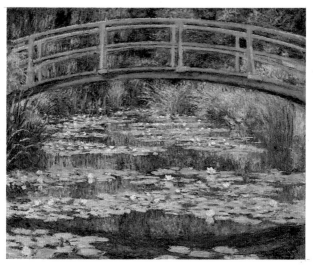

CLAUDE MONET (1840-1926)
*The Japanese Footbridge,* 1899
Oil on canvas, 32 x 40 in. (81.3 x 101.6 cm)

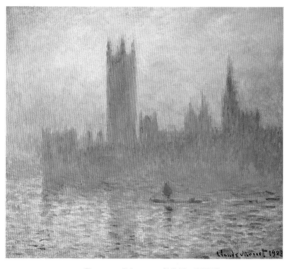

CLAUDE MONET (1840-1926)
*The Houses of Parliament, Sunset,* 1903
Oil on canvas, 32 x 36⅜ in. (81.3 x 92.5 cm)

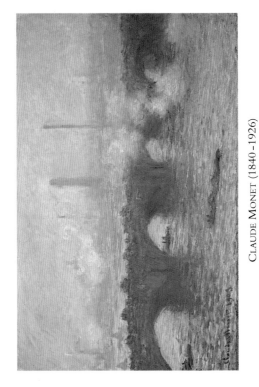

CLAUDE MONET (1840–1926)
*Waterloo Bridge, Gray Day*, 1903
Oil on canvas, 25⅝ x 39⅝ in. (65.1 x 100 cm)

CLAUDE MONET (1840–1926)
*Waterloo Bridge, London, at Dusk,* 1904
Oil on canvas, 25⅞ x 40 in. (65.7 x 101.6 cm)

CLAUDE MONET (1840–1926)
*Waterloo Bridge, London, at Sunset*, 1904
Oil on canvas, 25¾ x 36½ in. (65.5 x 92.7 cm)

CLAUDE MONET (1840–1926)
*Palazzo da Mula, Venice*, 1908
Oil on canvas, 24½ x 31⅞ in. (62 x 81.1 cm)

CAMILLE PISSARRO (1830–1903)
*Charing Cross Bridge, London*, 1890
Oil on canvas, 23⅝ x 36⅜ in. (60 x 92.4 cm)

CAMILLE PISSARRO (1830–1903)
*Hampton Court Green*, 1891
Oil on canvas, 21⅜ x 28¾ in. (54.3 x 73 cm)

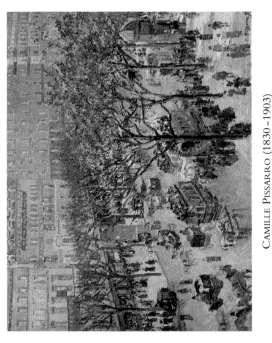

Camille Pissarro (1830–1903)
*Boulevard des Italiens, Morning, Sunlight*, 1897
Oil on canvas, 28⅞ x 36¼ in. (73.2 x 92.1 cm)

CAMILLE PISSARRO (1830–1903)
*The Artist's Garden at Eragny*, 1898
Oil on canvas, 29 x 36⅜ in. (73.6 x 92.3 cm)

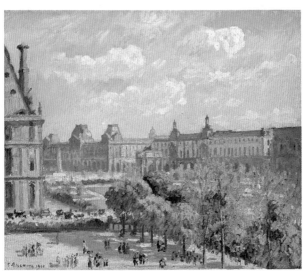

CAMILLE PISSARRO (1830–1903)
*Place du Carrousel, Paris,* 1900
Oil on canvas, 21⅝ x 25¾ in. (54.9 x 65.4 cm)

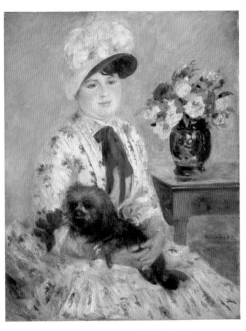

AUGUSTE RENOIR (1841–1919)
*Mademoiselle Charlotte Berthier,* 1883
Oil on linen, 36¼ x 28¾ in. (92.1 x 73 cm)

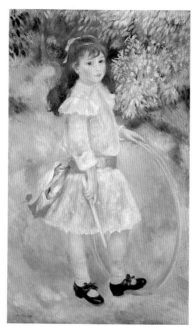

AUGUSTE RENOIR (1841-1919)
*Girl with a Hoop,* 1885
174    Oil on canvas, 49½ x 30⅛ in. (125.7 x 76.6 cm)

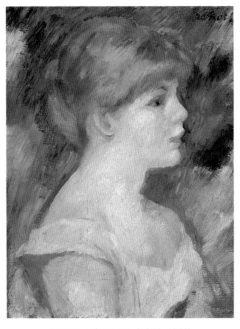

AUGUSTE RENOIR (1841–1919)
*Suzanne Valadon,* c. 1885
Oil on canvas, 16¼ x 12½ in. (41.2 x 31.8 cm)

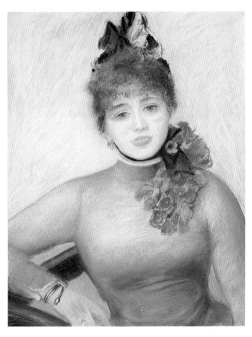

AUGUSTE RENOIR (1841–1919)
*Caroline Rémy ("Séverine"),* c. 1885
176     Pastel on paper, 24½ x 20 in. (62.3 x 50.8 cm)

AUGUSTE RENOIR (1841–1919)
*Studies of Trees,* 1886. Pen and black ink, watercolor, and
graphite on paper, 11⅞ x 8⅞ in. (30.1 x 22.4 cm)   177

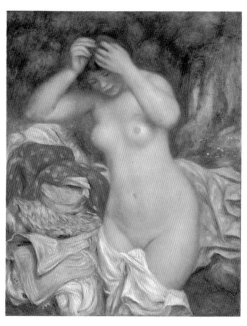

AUGUSTE RENOIR (1841–1919)
*Bather Arranging Her Hair,* 1893

Oil on canvas, 36⅜ x 29⅛ in. (92.2 x 73.9 cm)

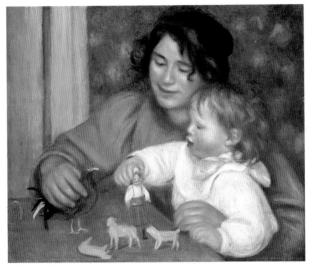

AUGUSTE RENOIR (1841-1919)
*Child with Toys—Gabrielle and the Artist's Son, Jean*, c. 1894
Oil on canvas, 21⅜ x 25¾ in. (54.3 x 65.4 cm)      179

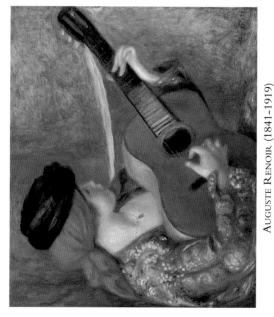

AUGUSTE RENOIR (1841–1919)
*Young Spanish Woman with a Guitar*, 1898
Oil on canvas, 21⅞ x 25⅝ in. (55.6 x 65.2 cm)

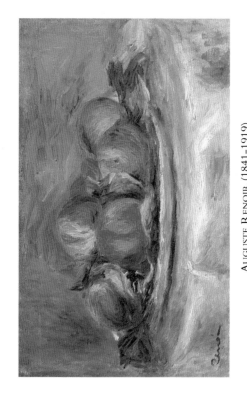

AUGUSTE RENOIR (1841–1919)
*Peaches on a Plate*, 1902/5
Oil on canvas, 8¾ x 14 in. (22.2 x 35.6 cm)

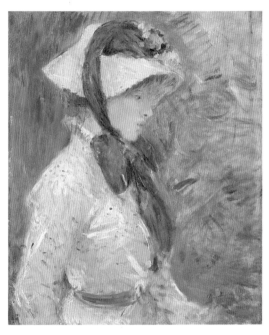

BERTHE MORISOT (1841–1895)
*Young Woman with a Straw Hat,* 1884
182   Oil on canvas, 21⅞ x 18⅜ in. (55.5 x 46.7 cm)

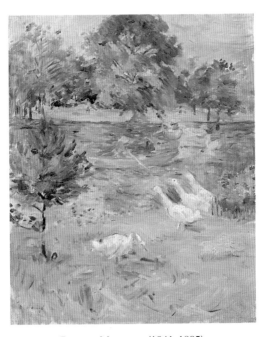

BERTHE MORISOT (1841–1895)
*Girl in a Boat with Geese*, c. 1889
Oil on canvas, 25¾ x 21½ in. (65.4 x 54.6 cm)

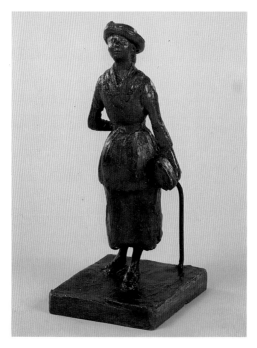

EDGAR DEGAS (1834–1917)
*The Schoolgirl (Woman Walking in the Street),* c. 1880/81
Red wax, height: 10½ in. (26.7 cm)

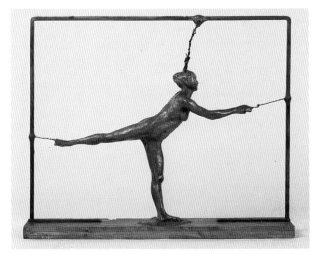

EDGAR DEGAS (1834–1917)
*Arabesque over the Right Leg, Left Arm in Front,* c. 1882/95
Yellow brown wax, metal frame, height: 11⅜ in. (28.9 cm)   185

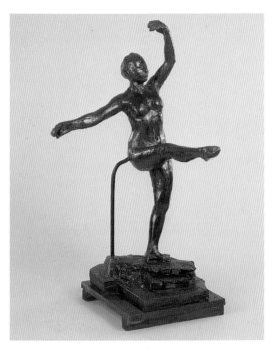

EDGAR DEGAS (1834–1917)
*Fourth Position Front, on the Left Leg,* c. 1883/88
Brown wax, cork, height: 22⅝ in. (57.5 cm)

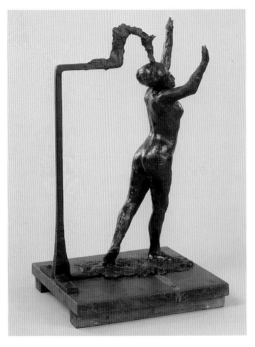

EDGAR DEGAS (1834–1917)
*Dancer Moving Forward, Arms Raised,* c. 1885/90. Greenish
black wax, metal armature, height: 13¾ in. (35 cm)    187

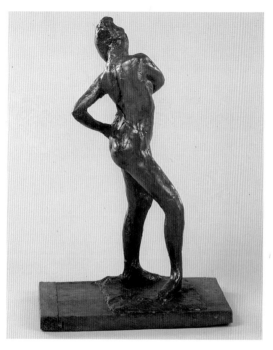

EDGAR DEGAS (1834–1917)
*Dancer Fastening the String of Her Tights,* c. 1885/90(?)
188    Yellow-brown plastilene, height: 16¾ in. (42.6 cm)

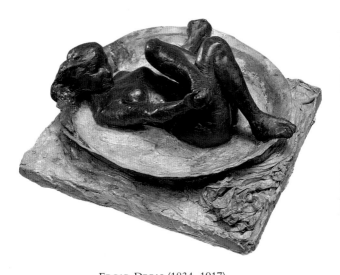

EDGAR DEGAS (1834–1917)
*The Tub,* 1889. Brownish red wax, lead, plaster of Paris, cloth,
diameter: 18½ in. (47 cm)

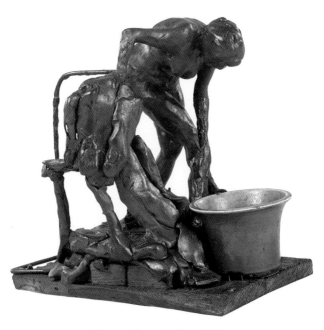

EDGAR DEGAS (1834–1917)
*Woman Washing Her Left Leg,* c. 1890
Yellow, red, and olive green wax, small green ceramic pot,
height: 7⅞ in. (20 cm)

EDGAR DEGAS (1834–1917)
*Four Dancers,* c. 1899
Oil on canvas, 59½ x 71 in. (151.1 x 180.2 cm)   191

EDGAR DEGAS (1834–1917)
*Before the Ballet*, 1890/92
Oil on canvas, 15¾ x 35 in. (40 x 88.9 cm)

EDGAR DEGAS (1834–1917)
*Ballet Scene*, c. 1907
Pastel on paper, 30¼ x 43¾ in. (76.8 x 111.2 cm)

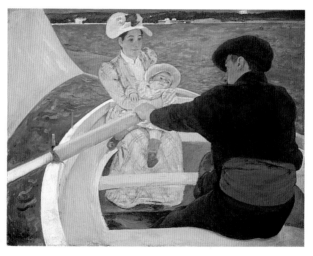

MARY CASSATT (1844–1926)
*The Boating Party*, 1893/94
194    Oil on canvas, 35½ x 46⅛ in. (90.2 x 117.1 cm)

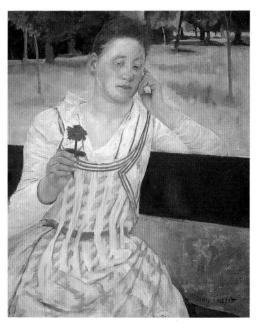

MARY CASSATT (1844–1926)
*Woman with a Red Zinnia,* 1891
Oil on canvas, 29 x 23¾ in. (73.6 x 60.3 cm)

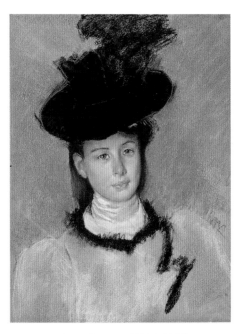

MARY CASSATT (1844–1926)
*The Black Hat,* c. 1890

Pastel on paper, 24 x 18 in. (61 x 45.5 cm)

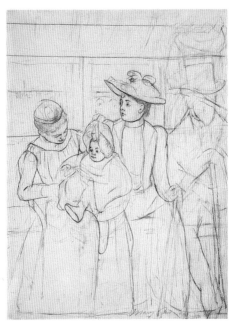

MARY CASSATT (1844–1926)
*In the Omnibus* (recto), c. 1891. Black chalk and graphite on
paper, 14⅞ x 10¾ in. (37.9 x 27.1 cm)

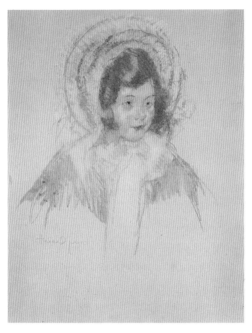

MARY CASSATT (1844–1926)
*Sara Wearing a Bonnet and Coat,* c.1904/6. Pastel counterproof,
198   reworked, on chine collé, 28¾ x 22⅞ in. (72.9 x 58.1 cm)

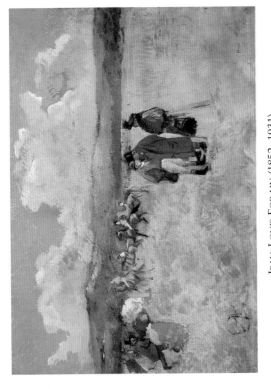

Jean-Louis Forain (1852–1931)
*The Race Track*, c. 1891
Gouache on paper, 31¾ x 45¼ in. (80.5 x 114.9 cm)

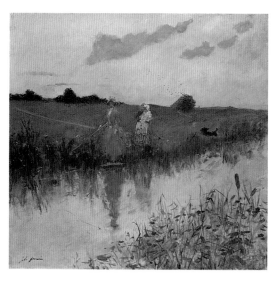

JEAN-LOUIS FORAIN (1852–1931)
*The Artist's Wife Fishing,* 1896
200   Oil on canvas, 37½ x 39⅞ in. (95.2 x 101.3 cm)

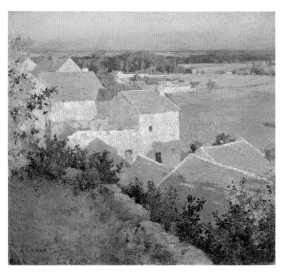

WILLARD LEROY METCALF (1858–1925)
*Midsummer Twilight*, c. 1885/87
Oil on canvas, 32¼ x 35⅜ in. (81.8 x 90.4 cm)

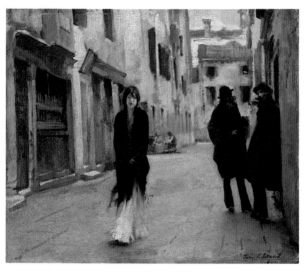

JOHN SINGER SARGENT (1856–1925)
*Street in Venice*, 1882
202     Oil on wood, 17¾ x 21¼ in. (45.1 x 53.9 cm)

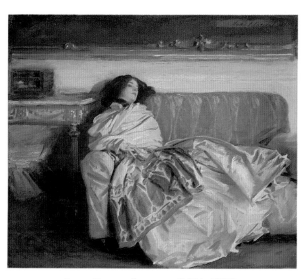

JOHN SINGER SARGENT (1856–1925)
*Repose,* 1911
Oil on canvas, 25⅛ x 30 in. (63.8 x 76.2 cm)

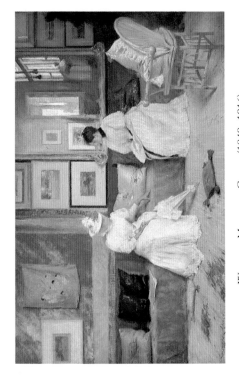

WILLIAM MERRITT CHASE (1849–1916)
*A Friendly Call*, 1895
Oil on canvas, 30⅛ x 48¼ in. (76.5 x 122.5 cm)

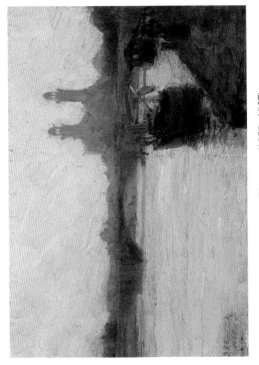

HENRY OSSAWA TANNER (1859–1937)
*The Seine*, 1902
Oil on canvas, 9 x 13 in. (23 x 32.9 cm)

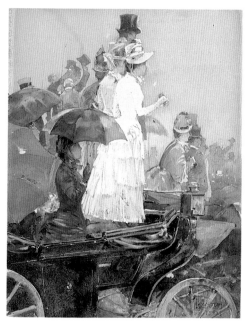

CHILDE HASSAM (1859-1935)

*Spectators at the Grand Prix*, 1888. Watercolor and gouache over
graphite on paper, sight size: 9 x 6¾ in. (23 x 17.5 cm)

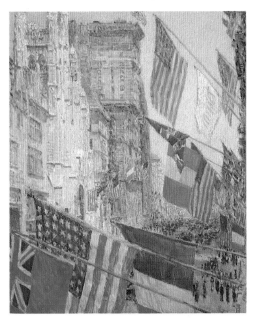

CHILDE HASSAM (1859–1935)
*Allies Day, May 1917*, 1917
Oil on canvas, 36½ x 30¼ in. (92.7 x 76.8 cm)

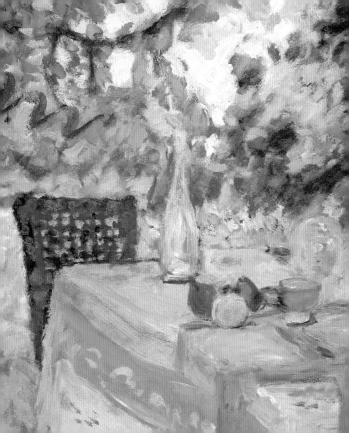

# THE POST-IMPRESSIONISTS

Though he had been a participant in the first Impressionist exhibition, Paul Cézanne became reclusive after the third group show in 1877, and he was working in virtual isolation as his meditative late style emerged. Late in life, when his fame was assured and his advice sought by younger artists, Cézanne made his famous assertion that he wanted to make Impressionism into "something solid and durable like the art of museums." He replaced the irregularity of his Impressionist brushwork with systematized notations that describe the underlying contours rather than the surface appearance of the subjects he painted.

Georges Seurat's *Sunday Afternoon on the Island of La Grande-Jatte* (Art Institute of Chicago), the most controversial work shown at the eighth Impressionist exhibition, was an astonishing display of his meticulous technique, called Neo-Impressionism or divisionism—a more scientifically objective form of Impressionism based on recent theories about the optical characteristics of light and color. In works he painted after 1886, Seurat was the first to explore deliberately the abstract qualities of the formal elements of painting, using light, color, and

line—independent of subject—to convey a particular mood.

The Symbolist movement was prevalent in contemporary French culture, and Vincent van Gogh and Paul Gauguin independently pursued goals affiliated to Symbolism, although in distinctively different ways. Emphatic, rhythmic brushwork and intense color and light in van Gogh's paintings create visual parallels for the artist's emotions, whereas Gauguin relied on the evocative power of abstracted shapes and unmodulated color to express universal ideas.

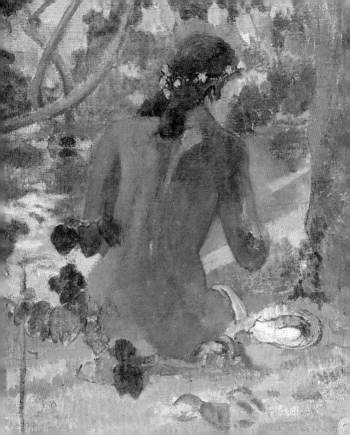

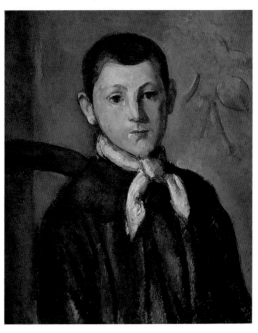

PAUL CÉZANNE (1839–1906)
*Louis Guillaume,* c. 1882

Oil on canvas, 22 x 18⅜ in. (55.9 x 46.7 cm)

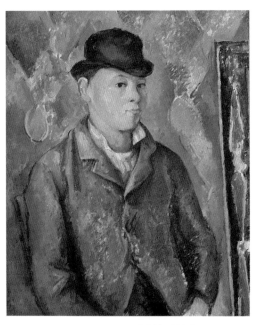

PAUL CÉZANNE (1839–1906)
*The Artist's Son, Paul*, 1885/90
Oil on canvas, 25¾ x 21¼ in. (65.3 x 54 cm)

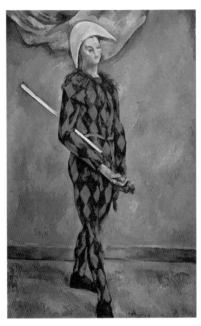

PAUL CÉZANNE (1839–1906)
*Harlequin*, 1888–90
214    Oil on canvas, 39⅞ x 25⅞ in. (101.1 x 65.7 cm)

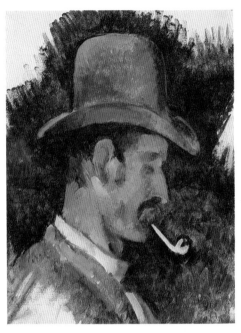

PAUL CÉZANNE (1839–1906)
*Man with Pipe,* 1892/96
Oil on canvas, 10¼ x 8 in. (26.1 x 20.2 cm)

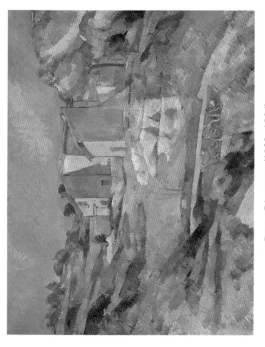

PAUL CÉZANNE (1839–1906)
*Houses in Provence*, c. 1880
Oil on canvas, 25⅝ x 32 in. (65 x 81.3 cm)

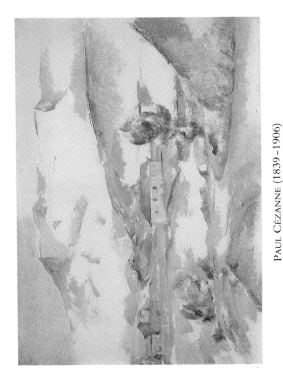

PAUL CÉZANNE (1839–1906)
*Mont Sainte-Victoire*, c. 1887
Oil on canvas, 26½ x 36 in. (67.2 x 91.3 cm)

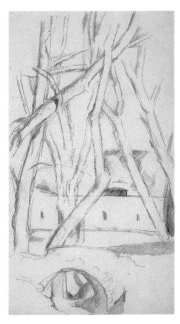

PAUL CÉZANNE (1839–1906)
*The Little Bridge* (recto), c. 1880
218  Graphite on paper, 8⅜ x 4⅞ in. (21.8 x 12.5 cm)

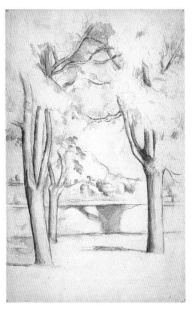

PAUL CÉZANNE (1839–1906)
*Mont Sainte-Victoire Seen beyond the Wall of the Jas de Bouffan*,
c. 1885/88. Watercolor and black chalk on paper,
sight size: 18 x 12 in. (46 x 30 cm)

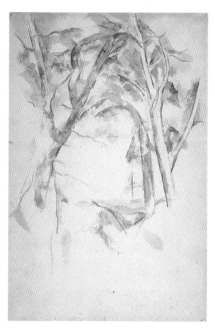

PAUL CÉZANNE (1839–1906)
*Trees Leaning over Rocks,* c. 1892. Watercolor and black chalk
on paper, 18½ x 12¼ in. (47.3 x 31.7 cm)

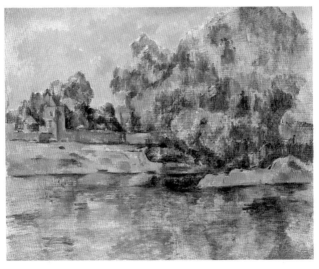

PAUL CÉZANNE (1839–1906)
*Riverbank,* c. 1895
Oil on canvas, 28¾ x 36⅜ in. (73 x 92.3 cm)

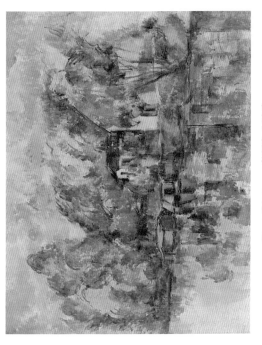

PAUL CÉZANNE (1839–1906)
*At the Water's Edge*, c. 1890
Oil on canvas, 28⅞ x 36½ in. (73.3 x 92.8 cm)

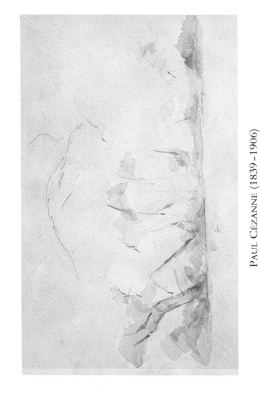

PAUL CÉZANNE (1839–1906)
*Mont Sainte-Victoire* (recto), c. 1895. Watercolor over graphite on paper, 8⅜ x 10⅞ in. (21.1 x 27.4 cm)

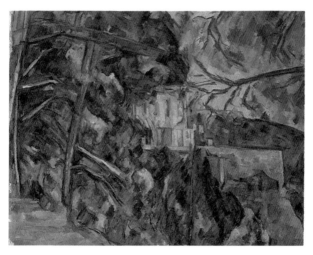

PAUL CÉZANNE (1839–1906)
*Le Château Noir,* 1900/1904
Oil on canvas, 29 x 38 in. (73.7 x 96.6 cm)

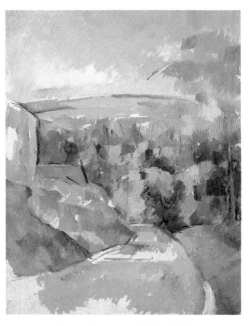

PAUL CÉZANNE (1839–1906)
*Bend in the Road,* 1900–1906
Oil on canvas, 32⅜ x 26 in. (82.1 x 66 cm)

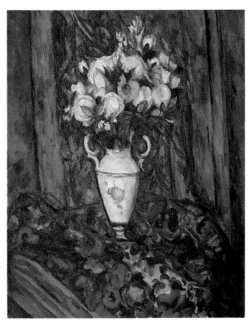

Paul Cézanne (1839–1906)
*Vase of Flowers,* 1900/1903
Oil on canvas, 39¾ x 32¼ in. (101 x 81.9 cm)

226

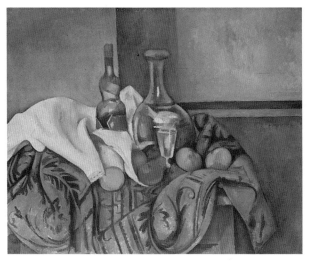

PAUL CÉZANNE (1839–1906)
*Still Life with Peppermint Bottle,* c. 1894
Oil on canvas, 26 x 32⅜ in. (65.9 x 82.1 cm)            227

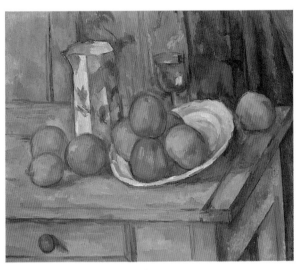

PAUL CÉZANNE (1839–1906)
*Still Life,* c. 1900
Oil on canvas, 18 x 21⅜ in. (45.8 x 54.9 cm)

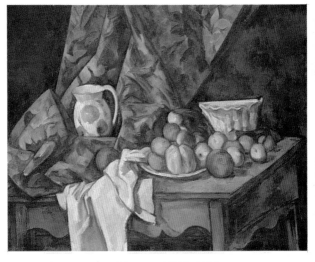

PAUL CÉZANNE (1839–1906)
*Still Life with Apples and Peaches,* c. 1905
Oil on canvas, 31⅞ x 39⅝ in. (81 x 100.5 cm)

GEORGES SEURAT (1859–1891)
*Study for "La Grande Jatte,"* 1884/85
Oil on wood, 6¼ x 9⅞ in. (15.9 x 25 cm)

GEORGES SEURAT (1859–1891)
*The Lighthouse at Honfleur*, 1886
Oil on canvas, 26¼ x 32¼ in. (66.7 x 81.9 cm)

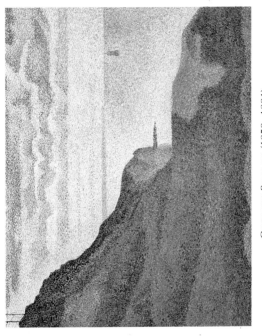

GEORGES SEURAT (1859–1891)
*Seascape at Port-en-Bessin, Normandy*, 1888
Oil on canvas, 25⅝ x 31⅞ in. (65.1 x 80.9 cm)

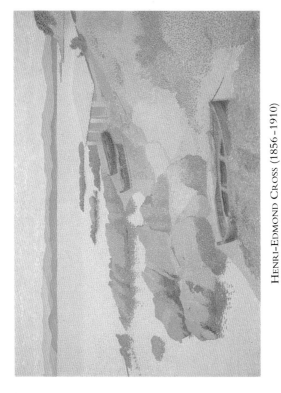

HENRI-EDMOND CROSS (1856–1910)
*Coast near Antibes*, 1891/92
Oil on canvas, 25⅝ x 36⅜ in. (65.1 x 92.3 cm)

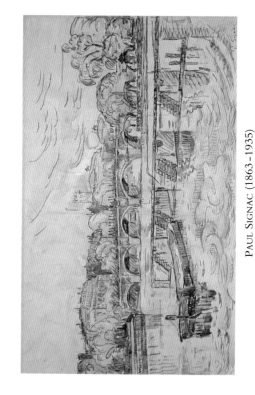

PAUL SIGNAC (1863–1935)
*Pont Neuf, Paris,* n.d. Watercolor over black chalk on paper,
approximately 11½ x 17⅞ in. (29.2 x 45.4 cm)

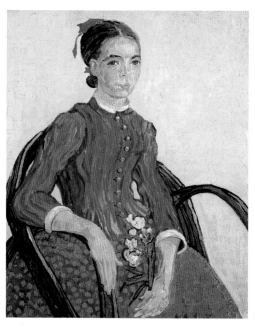

VINCENT VAN GOGH (1853–1890)
*La Mousmé,* 1888
Oil on canvas, 28⅞ x 23¾ in. (73.3 x 60.3 cm)

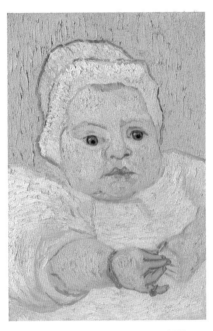

VINCENT VAN GOGH (1853–1890)
*Roulin's Baby,* 1888
Oil on canvas, 13¾ x 9⅜ in. (35 x 23.9 cm)

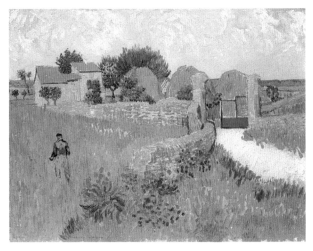

VINCENT VAN GOGH (1853–1890)
*Farmhouse in Provence, Arles,* 1888
Oil on canvas, 18⅛ x 24 in. (46.1 x 60.9 cm)

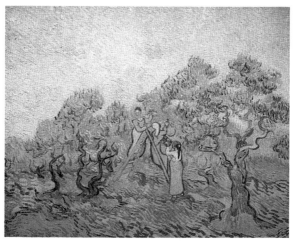

VINCENT VAN GOGH (1853–1890)
*The Olive Orchard,* 1889
Oil on canvas, 28¾ x 36¼ in. (73 x 92.1 cm)

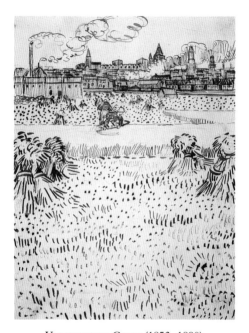

VINCENT VAN GOGH (1853–1890)
*The Harvest*, 1888. Pen and brown ink over graphite on paper,
12½ x 9½ in. (31.7 x 24.2 cm)

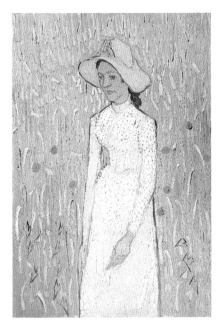

VINCENT VAN GOGH (1853–1890)
*Girl in White,* 1890
240     Oil on linen, 26⅛ x 17⅞ in. (66.3 x 45.3 cm)

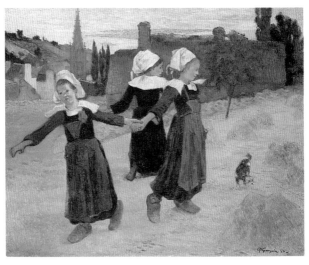

PAUL GAUGUIN (1848–1903)
*Breton Girls Dancing, Pont-Aven,* 1888
Oil on canvas, 28¾ x 36½ in. (73 x 92.7 cm)

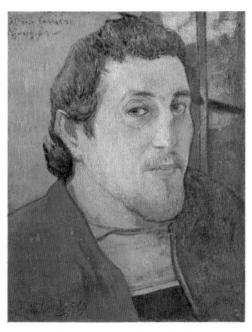

PAUL GAUGUIN (1848–1903)
*Self-Portrait Dedicated to Carrière,* 1888/89
Oil on canvas, 18⅜ x 15¼ in. (46.5 x 38.6 cm)

242

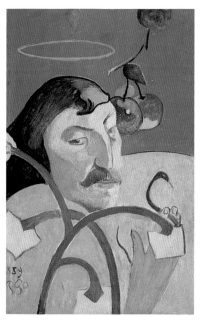

PAUL GAUGUIN (1848–1903)
*Self-Portrait*, 1889
Oil on wood, 31¼ x 20¼ in. (79.2 x 51.3 cm)

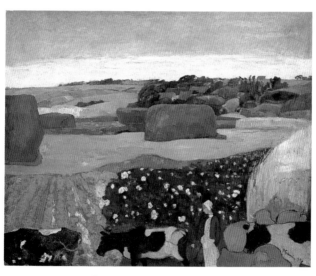

PAUL GAUGUIN (1848–1903)
*Haystacks in Brittany*, 1890
244    Oil on canvas, 29¼ x 36⅞ in. (74.3 x 93.6 cm)

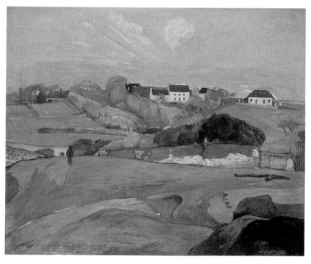

PAUL GAUGUIN (1848–1903)
*Landscape at Le Pouldu*, 1890
Oil on canvas, 28⅞ x 36⅜ in. (73.3 x 92.4 cm)

245

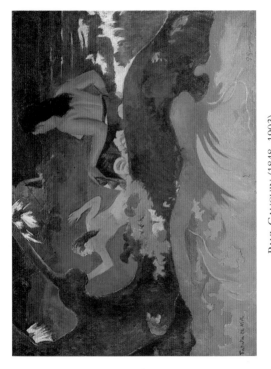

PAUL GAUGUIN (1848–1903)
*Fatata te Miti (By the Sea)*, 1892
Oil on canvas, 26¾ x 36 in. (67.9 x 91.5 cm)

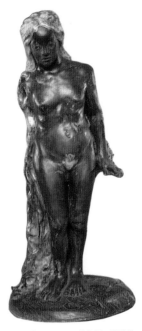

PAUL GAUGUIN (1848–1903)
*Eve,* 1890. Ceramic, painted,
23⅞ x 11 x 10¾ in. (60.6 x 27.9 x 27.3 cm)

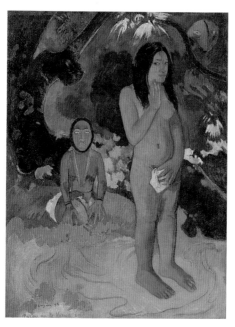

PAUL GAUGUIN (1848–1903)
*Parau na te Varua Ino (Words of the Devil),* 1892
Oil on canvas, 36⅛ x 27 in. (91.7 x 68.5 cm)

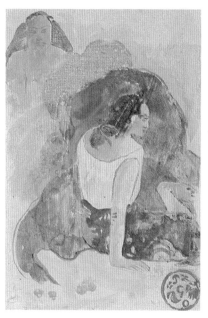

PAUL GAUGUIN (1848–1903)
*Arearea no Varua Ino (Words of the Devil)* (recto), 1894
Watercolor monotype, 9⅝ x 6⅝ in. (24.4 x 16.6 cm)    249

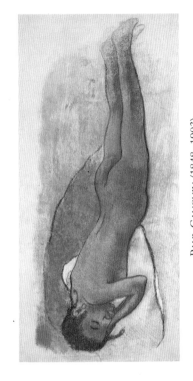

PAUL GAUGUIN (1848–1903)
*Reclining Nude* (recto), 1894/95. Charcoal, black chalk, and pastel on paper, 12⅛ x 24½ in. (30.6 x 62.1 cm)

PAUL GAUGUIN (1848–1903)
*The Bathers*, 1897
Oil on canvas, 23¾ x 36¾ in. (60.4 x 93.4 cm)

PAUL GAUGUIN (1848–1903)
*Nave Nave Fenua,* c. 1894/1900. Gouache and india ink on
paper, approximately 16⅜ x 10⅜ in. (42.2 x 26.2 cm)

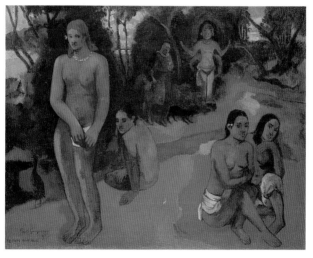

PAUL GAUGUIN (1848–1903)
*Te Pape Nave Nave (Delectable Waters)*, 1898
Oil on canvas, 29⅛ x 37½ in. (74 x 95.3 cm)

PAUL GAUGUIN (1848–1903)
*Père Paillard,* c. 1902
Oil on wood, 26¾ x 7⅛ x 8⅛ in. (67.9 x 18 x 20.7 cm)

PAUL GAUGUIN (1848–1903)

*The Pony*, c. 1902. Gouache monotype, with addition of gum or varnish, 12⅞ x 23½ in. (32.7 x 59.5 cm)

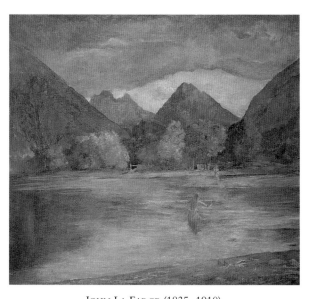

JOHN LA FARGE (1835–1910)
*The Entrance to the Tautira River, Tahiti. Fishermen
Spearing a Fish*, c. 1895

Oil on canvas, 53½ x 60 in. (135.9 x 152.3 cm)

HENRI DE TOULOUSE-LAUTREC (1864–1901)
*The Artist's Dog Flèche*, c. 1881
Oil on wood, 9¼ x 5½ in. (23.4 x 14.1 cm)

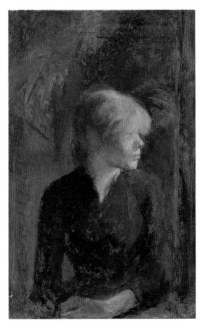

HENRI DE TOULOUSE-LAUTREC (1864–1901)
*Carmen Gaudin*, 1885
Oil on wood, 9⅜ x 5⅞ in. (23.8 x 14.9 cm)

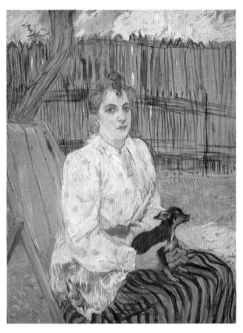

HENRI DE TOULOUSE-LAUTREC (1864–1901)
*Lady with a Dog*, 1891
Oil on cardboard, 29½ x 22½ in. (75 x 57.2 cm)    259

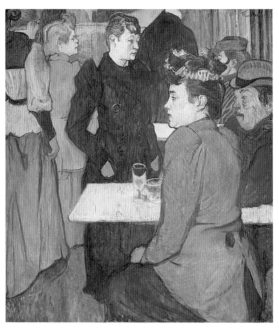

HENRI DE TOULOUSE-LAUTREC (1864–1901)
*A Corner of the Moulin de la Galette*, 1892. Oil on cardboard on
wood, 39½ x 35⅛ in. (100.3 x 89.1 cm)

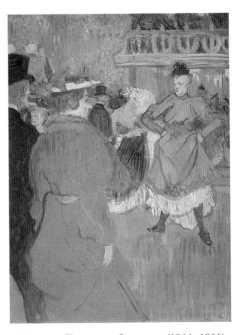

HENRI DE TOULOUSE-LAUTREC (1864–1901)
*Quadrille at the Moulin Rouge,* 1892
Oil on cardboard, 31½ x 23¾ in. (80.1 x 60.5 cm)

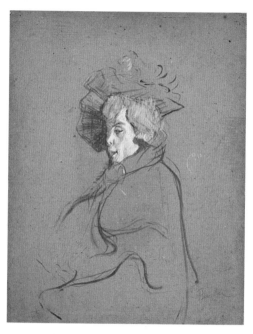

HENRI DE TOULOUSE-LAUTREC (1864-1901)
*Jane Avril*, 1892. Oil on cardboard mounted on wood,
26¾ x 20⅞ in. (67.8 x 52.9 cm)

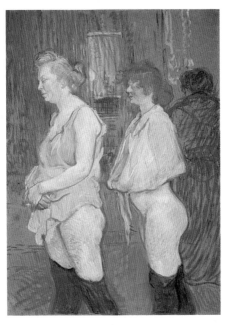

HENRI DE TOULOUSE-LAUTREC (1864–1901)
*Rue des Moulins,* 1894. Oil on cardboard on wood,
32⅞ x 24⅛ in. (83.5 x 61.4 cm)

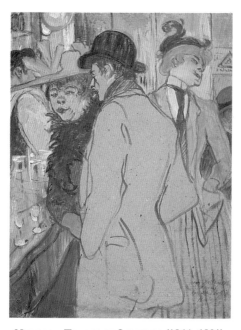

HENRI DE TOULOUSE-LAUTREC (1864–1901)
*Alfred la Guigne,* 1894
264    Oil on cardboard, 25¾ x 19¾ in. (65.6 x 50.4 cm)

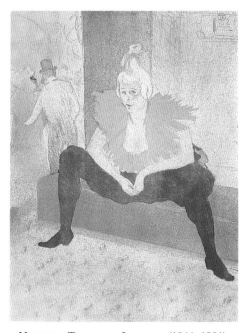

HENRI DE TOULOUSE-LAUTREC (1864–1901)
*Seated Clowness,* 1896
Color lithograph, sheet: 20½ x 15¾ in. (51.8 x 40 cm)   265

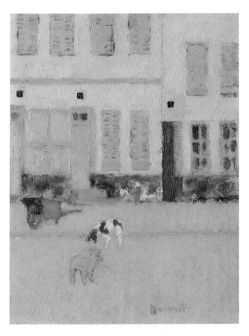

PIERRE BONNARD (1867–1947)
*Two Dogs in a Deserted Street,* c. 1894
266     Oil on wood, 13⅞ x 10⅝ in. (35.1 x 27 cm)

PIERRE BONNARD (1867–1947)
*Woman with an Umbrella,* 1895
Lithograph, image: 8 x 4 in. (21 x 10 cm)

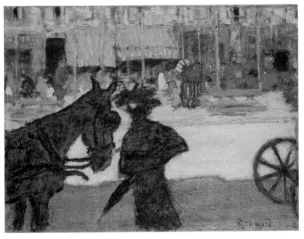

PIERRE BONNARD (1867–1947)
*The Cab Horse,* c. 1895
Oil on wood, 11¾ x 15¾ in. (29.7 x 40 cm)

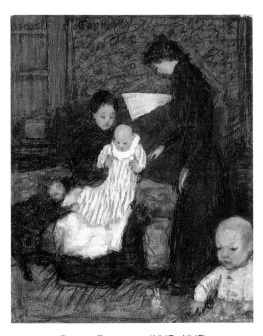

PIERRE BONNARD (1867–1947)
*The Artist's Sister and Her Children,* 1898
Oil on cardboard on wood, 12 x 10 in. (30.5 x 25.4 cm)   269

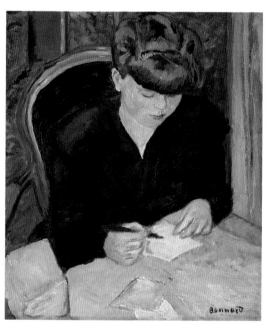

PIERRE BONNARD (1867–1947)
*The Letter,* c. 1906
Oil on canvas, 21⅝ x 18¾ in. (55 x 47.5 cm)

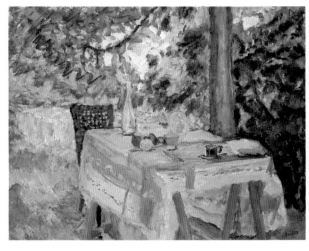

PIERRE BONNARD (1867–1947)
*Table Set in a Garden,* c. 1908. Oil on paper mounted on
canvas, 19½ x 25½ in. (49.5 x 64.7 cm)

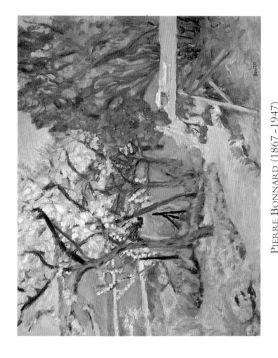

PIERRE BONNARD (1867–1947)
*The Green Table*, c. 1910
Oil on canvas, 20⅛ x 25⅝ in. (51.1 x 65.1 cm)

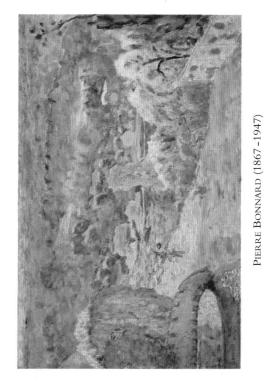

PIERRE BONNARD (1867–1947)
*A Spring Landscape*, c. 1935
Oil on canvas, 26⅝ x 40½ in. (67.6 x 103 cm)

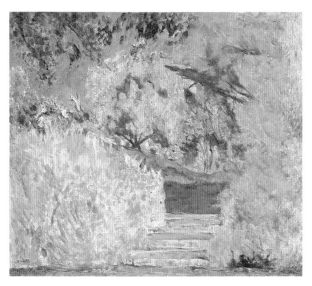

PIERRE BONNARD (1867–1947)
*Stairs in the Artist's Garden,* 1942/44
274    Oil on canvas, 24⅞ x 28¾ in. (63.3 x 73.1 cm)

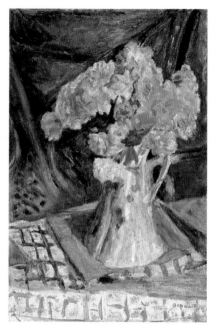

PIERRE BONNARD (1867–1947)
*Bouquet of Flowers*, c. 1926
Oil on canvas, 27⅝ x 18⅝ in. (70.3 x 47.4 cm)

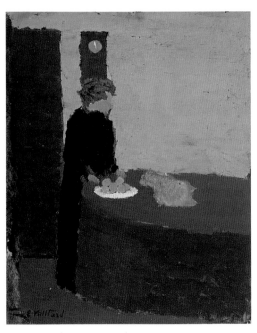

EDOUARD VUILLARD (1868–1940)
*Woman in Black,* c. 1891

276   Oil on cardboard, 10½ x 8⅜ in. (26.8 x 21.9 cm)

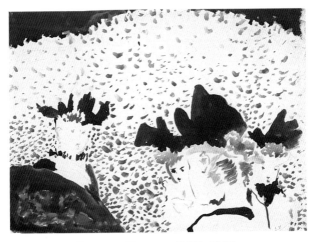

EDOUARD VUILLARD (1868–1940)
*Four Ladies with Fancy Hats*, 1892/93. Watercolor over graphite
on paper, 8⅜ x 11⅝ in. (21.2 x 29.5 cm)          277

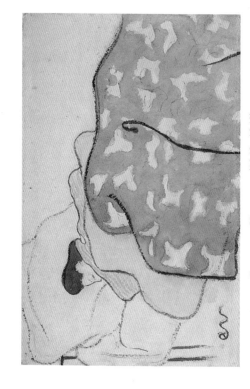

EDOUARD VUILLARD (1868–1940)
*Woman in Bed*, n.d.
Watercolor on paper, 5⅞ x 9 in. (14.7 x 22.8 cm)

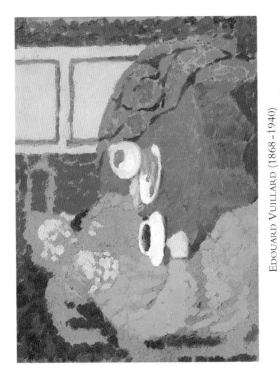

EDOUARD VUILLARD (1868–1940)
*Two Women Drinking Coffee*, c. 1893. Oil on cardboard on wood, 8½ x 11⅛ in. (21.5 x 28.8 cm)

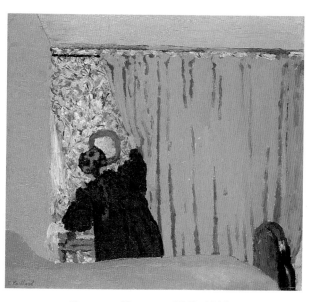

EDOUARD VUILLARD (1868–1940)
*The Yellow Curtain,* c. 1893
280 Oil on canvas, 13¾ x 15⅜ in. (34.9 x 39 cm)

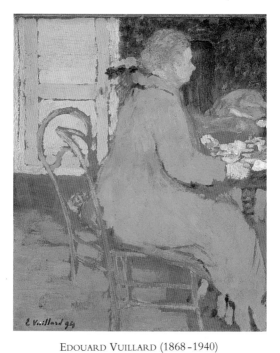

EDOUARD VUILLARD (1868–1940)
*Breakfast,* 1894
Oil on cardboard on wood, 10⅝ x 9 in. (26.9 x 22.9 cm)  281

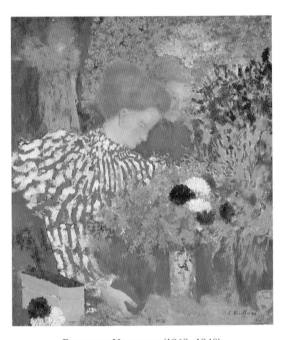

EDOUARD VUILLARD (1868–1940)
*Woman in a Striped Dress,* 1895
282   Oil on canvas, 25⅞ x 23⅛ in. (65.7 x 58.7 cm)

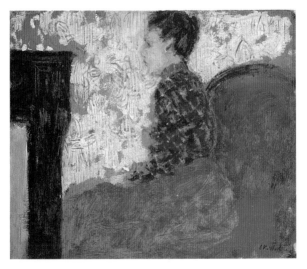

EDOUARD VUILLARD (1868–1940)
*Woman Sitting by the Fireside,* c. 1894
Oil on cardboard, 8⅜ x 10¼ in. (21.3 x 26.1 cm)

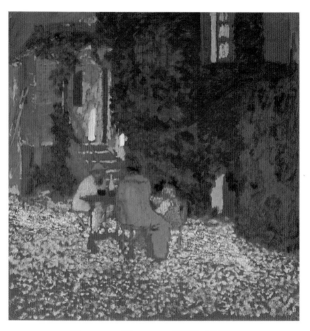

EDOUARD VUILLARD (1868–1940)
*Repast in a Garden,* 1898
Gouache on cardboard, 21⅜ x 20⅞ in. (54.3 x 53.1 cm)

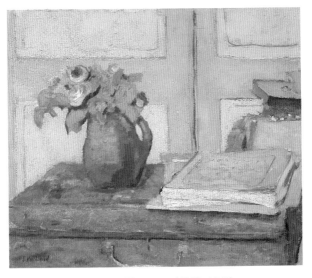

EDOUARD VUILLARD (1868–1940)
*The Artist's Paint Box and Moss Roses*, 1898
Oil on cardboard, 14¼ x 16⅞ in. (36.1 x 42.9 cm)     285

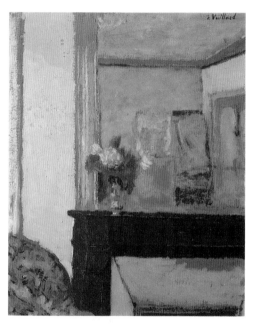

EDOUARD VUILLARD (1868–1940)
*Vase of Flowers on a Mantelpiece,* c. 1900. Oil on cardboard on
wood, 14¼ x 11⅝ in. (36.2 x 29.5 cm)

KER-XAVIER ROUSSEL (1867-1944)
*Landscape with a Lady in a Striped Dress,* c. 1898
Pastel on paper, 11⅛ x 14⅜ in. (28.2 x 36.5 cm)     287

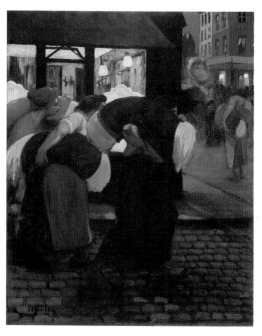

THÉOPHILE-ALEXANDRE STEINLEN (1859–1923)
*The Laundresses*, 1899

Oil on canvas, 33¾ x 26⅞ in. (83.2 x 68.2 cm)

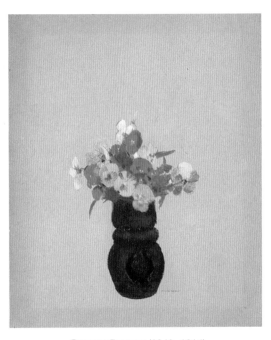

ODILON REDON (1840–1916)
*Pansies,* c. 1905
Pastel on paper, 21⅞ x 18⅝ in. (55.7 x 47.1 cm)     289

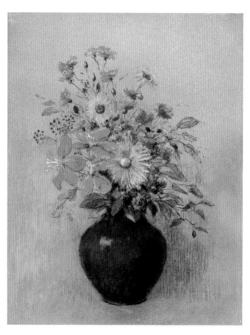

ODILON REDON (1840–1916)
*Wildflowers*, c. 1905
290    Pastel on paper, 24⅞ x 19¾ in. (64.1 x 50 cm)

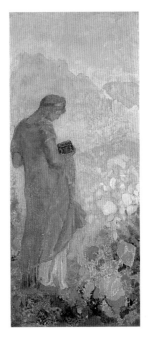

ODILON REDON (1840–1916)
*Pandora,* 1910/12
Oil on linen, 56½ x 24¾ in. (143.6 x 62.9 cm)    291

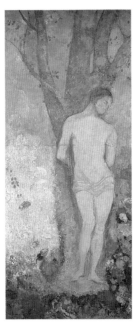

ODILON REDON (1840–1916)
*Saint Sebastian,* 1910/12
Oil on linen, 56¾ x 24¾ in. (144 x 62.8 cm)

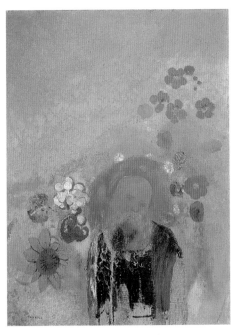

ODILON REDON (1840–1916)
*Evocation of Roussel,* c. 1912
Oil on linen, 28⅞ x 21⅜ in. (73.4 x 54.3 cm)    293

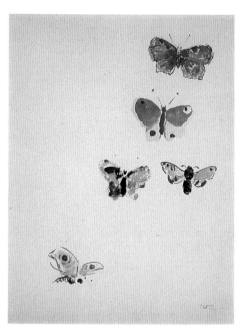

ODILON REDON (1840–1916)
*Five Butterflies,* c. 1912. Watercolor on paper,
sight size: 10½ x 8 in. (26.5 x 20.5 cm)

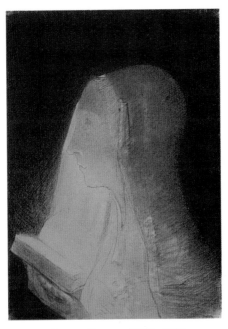

ODILON REDON (1840–1916)
*Head of a Veiled Woman*, n.d. Charcoal on paper,
20½ x 14¾ in. (52.2 x 37.5 cm)

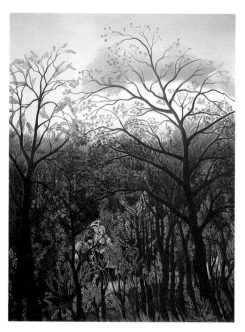

Henri Rousseau (1844–1910)
*Rendezvous in the Forest,* 1889
Oil on canvas, 36¼ x 28¾ in. (92 x 73 cm)

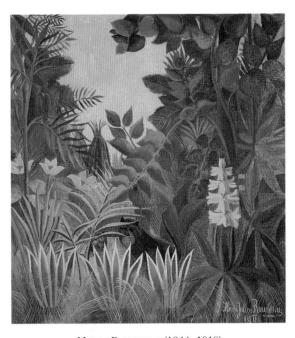

HENRI ROUSSEAU (1844–1910)
*The Equatorial Jungle,* 1909
Oil on canvas, 55¼ x 51 in. (140.6 x 129.5 cm)     297

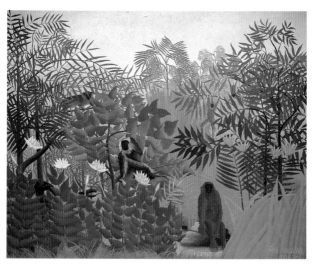

HENRI ROUSSEAU (1844–1910)
*Tropical Forest with Monkeys,* 1910
298    Oil on canvas, 51 x 64 in. (129.5 x 162.6 cm)

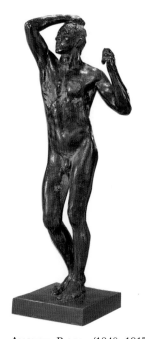

AUGUSTE RODIN (1840–1917)
*The Age of Bronze,* late 1890s
Bronze, 41 x 14 x 8⅝ in. (104.1 x 35.5 x 21.9 cm)     299

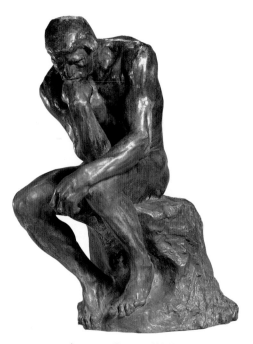

Auguste Rodin (1840–1917)
*The Thinker,* 1880
Bronze, 28⅛ x 14⅜ x 23½ in. (71.5 x 36.4 x 59.5 cm)

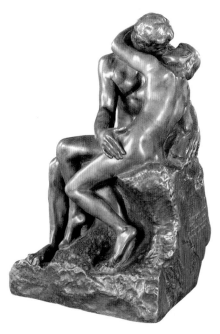

AUGUSTE RODIN (1840–1917)
*The Kiss,* 1880–87
Bronze, 9¾ x 6¼ x 6⅞ in. (24.7 x 15.8 x 17.4 cm)   301

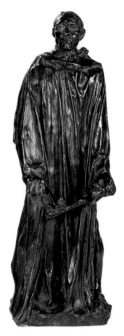

AUGUSTE RODIN (1840-1917)
*A Burgher of Calais,* late 1890s

302    Bronze, 18½ x 6¼ x 5½ in. (47 x 16 x 14 cm)

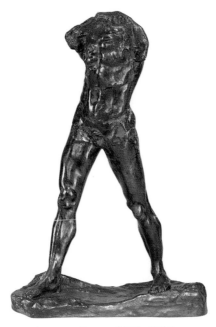

AUGUSTE RODIN (1840–1917)
*The Walking Man,* probably c. 1900
Bronze, 33¼ x 16¾ x 21⅞ in. (84.5 x 42.6 x 55.5 cm)   303

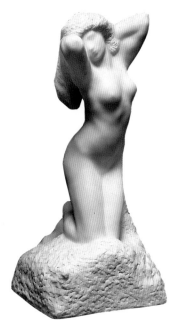

Auguste Rodin (1840–1917)
*Morning,* 1906
Marble, 23¾ x 11¼ x 13⅛ in. (60.4 x 28.7 x 33.3 cm)

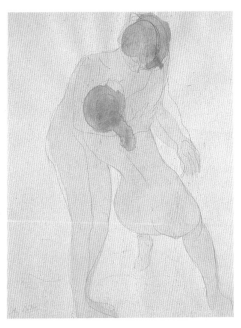

Auguste Rodin (1840–1917)
*Two Figures*, n.d. Graphite with wash on paper,
12⅞ x 9⅞ in. (32.7 x 25 cm)

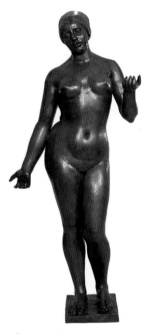

ARISTIDE MAILLOL (1861–1944)
*Summer,* 1910
306    Bronze, 64⅛ x 29 x 13 in. (163 x 73.7 x 33.2 cm)

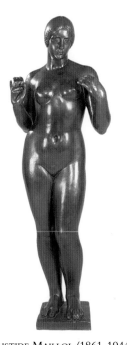

ARISTIDE MAILLOL (1861–1944)
*Venus,* 1918/28
Bronze, 69⅛ x 23¾ x 16⅝ in. (175.5 x 60.2 x 42.3 cm)   307

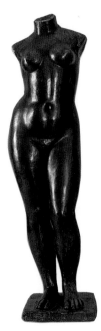

ARISTIDE MAILLOL (1861–1944)
*Torso of Venus,* probably c. 1918/28
Bronze, height: 61⅛ in. (155.3 cm)

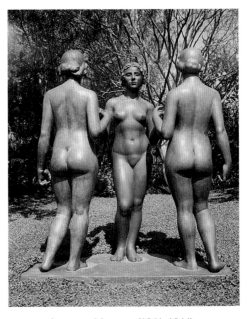

ARISTIDE MAILLOL (1861–1944)
*The Three Nymphs*, 1930-38
Lead, 62 x 57⅜ x 31½ in. (157.5 x 145.7 x 80 cm)   309

# INDEX OF DONORS' CREDITS

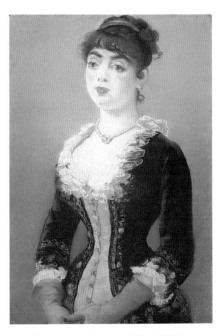

EDOUARD MANET (1832–1883)
*Madame Michel-Lévy,* 1882
Pastel and oil on canvas, 29¼ x 20⅛ in. (74.4 x 51 cm)    311

# INDEX OF ILLUSTRATIONS

317

First edition

10  9  8  7  6  5  4

*Library of Congress Cataloging-in-Publication Data*
Coman, Florence E.
    Treasures of impressionism and post-impressionism from the National Gallery
of Art / Florence E. Coman ; foreword by Earl A. Powell III.
    p.    cm.
    Includes index.
    ISBN 1–55859–561–9
    1. Impressionism (Art)—France—Catalogs. 2. Post-impressionism (Art)—
France—Catalogs. 3. Art, French—Catalogs. 4. Art, Modern—19th
century—France—Catalogs. 5. Art, Modern—20th century—France—
Catalogs. 6. Art—Washington (D.C.)—Catalogs. 7. National Gallery
of Art (U.S.)—Catalogs. I. National Gallery of Art (U.S.) II. Title.
N6847.5.I4C66  1993
709'. 44'074753—dc20                                         93-10768